IMAGES
of America

PEARISBURG AND GILES COUNTY

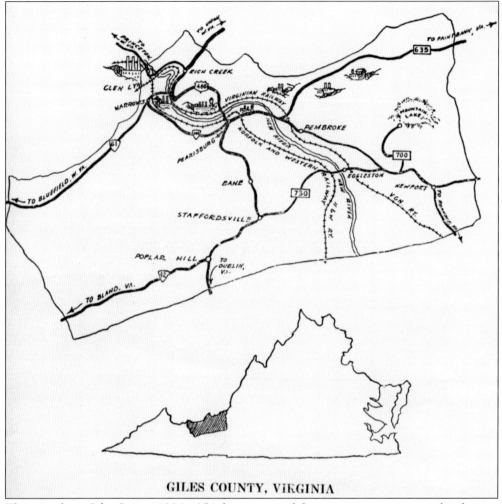

GILES COUNTY, VIRGINIA

This map from *Giles County 1806–1956* shows some of the many communities and industries in Giles County. The New River, Norfolk and Western Railway, Virginian Railway, U.S. 460, and Route 100 are the main routes through the county. There are many other creeks, roads, and railroads that create smaller communities in Giles County that are not shown. (Goldwaithe.)

ON THE COVER: Giles County celebrated its centennial in 1906 with a parade. Shown here is J. H. Woolwine Hardware and Feed Company's entry in the parade. The group traveled the five miles from Narrows to be in the parade and is shown in front of the Woolwine house in Pearisburg. (GCHS.)

IMAGES
of America

PEARISBURG AND GILES COUNTY

Terri L. Fisher

ARCADIA
PUBLISHING

Copyright © 2008 by Terri L. Fisher
ISBN 978-0-7385-5373-3

Published by Arcadia Publishing
Charleston SC, Chicago IL, Portsmouth NH, San Francisco CA

Printed in the United States of America

Library of Congress Catalog Card Number: 2007940136

For all general information contact Arcadia Publishing at:
Telephone 843-853-2070
Fax 843-853-0044
E-mail sales@arcadiapublishing.com
For customer service and orders:
Toll-Free 1-888-313-2665

Visit us on the Internet at www.arcadiapublishing.com

*To Terry, without whom I would not have found
my way to Giles County*

CONTENTS

ACKNOWLEDGMENTS

A number of people deserve thanks in helping me bring this book to fruition. Abbreviations following names are used to identify photograph owners in the captions. First and foremost, thanks go to the board of directors of the Giles County Historical Society (GCHS): In giving me the opportunity to step in when they needed help, they gave me the chance to write this book, unlimited access to the books and photographs in the historical society's collection, and contacts with people with historical knowledge and photographs. Thanks to Jane Wills with the Digital Library and Archives at Virginia Tech (DLA), who was very patient and accommodating in all of my requests for images, and to Rhonda Broom at Norfolk Southern (DLA-NS), who provided permission to use railroad images housed at Virginia Tech. Thank you to Birdie Moye at Pearisburg Public Library (PPL) and Darlene Gautier at Rich Creek Public Library (RCPL) for trusting me to take photographs home to scan. Thank you to C. G. Thomas (CGT), Doug Martin (DM), Estelle Woodbury (EW), and Cornelia Smith of the Narrows Centennial Committee (NCC) for providing photographs. In addition to the above sources, photographs in the book appear from the Library of Congress, Prints and Photographs Division, Historic American Engineering Record (HAER VA-126 and HAER VA, 36-PEMB.V) and Panoramic Photographs Collection (PAN US GEOG–Virginia). A big thank you also goes to Temple Lawrence for her help in identifying some of the old photographs, especially those in Pearisburg; to Jim Walker for fortuitously visiting the historical society offering a book of Mountain Lake photographs; to Brooksi Hudson at Arcadia Publishing for her gentle prodding and consideration as my deadline slipped; and most importantly, to my husband, Terry Nicholson (TKN), for his patience, love, and understanding as I overcommitted myself this year. While I tried to gather photographs from as many of Giles County's communities as I could, I know that I have missed some. I am sure that many more photographs will surface after this is published. Please bring them to the historical society and help us build our archives and public knowledge of the history of Giles County!

INTRODUCTION

It was nearly 150 years after the settlement of Jamestown that settlers of European descent began populating the area that would become Giles County. A grave marker said to have been found at Glen Lyn explains one reason for this late settlement: "Mary Porter was killed by the Indians November 28, 1742." The New River provided a relatively level highway for Native Americans, explorers, and hunters to travel through the rugged mountains on their way west. A famous follower of the New River was Mary Draper Ingles, a settler from Draper's Meadows, now Blacksburg, who was captured by Shawnees and taken to Bone Lick, Kentucky. She escaped and followed 450 miles of the Ohio, Kanawha, and New Rivers to Adam Harmon's settlement in what is now Eggleston before being rescued in his cornfield in 1755.

Early settlers of Giles County, such as the Porters and the Harmons, generally settled around bodies of water such as the New River, Sinking Creek, Wolf Creek, Walker Creek, and Spruce Run. The water was used to power grist and lumber mills that were often the foundation for small communities. Where the river had not cut through limestone cliffs, it often left rich, relatively level bottomland. Though the land was prone to flooding, it also provided fertile fields for growing crops and grazing animals.

By the early 1800s, area settlers had grown tired of traveling to the Montgomery County seat in Christiansburg to do business. Giles County was formed in 1806 from portions of Montgomery, Tazewell, and Monroe Counties and was named for William Branch Giles, a member of Congress and governor of Virginia. The first county court met roughly in the center of the county in a log house at the home of George Pearis near today's Bluff City on the New River. Pearis had extensive land holdings along the New River and offered 53 acres for the county seat as well as the timber and stone needed to build a courthouse there.

Pearisburg, known for a time as Giles Court House, was established in 1808 and originally contained just four blocks. The public square contained the courthouse and a jail. Stores, hotels, and other services eventually developed around the courthouse to accommodate those who came to town on business. Since travel was difficult and time-consuming, many who visited the courthouse would stay overnight, taking the opportunity to conduct other business while there. Pearisburg soon became a commercial center.

Early roads, such as the Cumberland Gap Turnpike, Giles-Fayette-Kanawha Turnpike, Pulaski-Giles Turnpike, and Mountain Lake–Salt Sulphur Springs Turnpike connected courthouses to facilitate government and business transactions and provided paths for settlers headed west. Roads were rough, rutted, and narrow, passing through mountainous terrain and crossing rivers and creeks via ford and ferry.

Not everyone was traveling to Giles County on business, however. By the 1830s, people were traveling west to reach the springs resorts near what is now the Virginia–West Virginia border. Eggleston Springs Resort, on the New River, provided white sulphur springwater for patients wishing to cure diseases of the skin, laryngitis, gout, rheumatism, stiff joints, old gunshot wounds, hemorrhoids, and syphilis, among other undesirable situations.

By the 1850s, it had become fashionable to visit the mountain springs resorts. People came for the fresh mountain air, the scenery, and to socialize with others of their class. Mountain Lake Resort was built at this time in the same spirit of resort life. On the turnpike to the springs resorts of today's West Virginia, Mountain Lake did not have a spring but did have a lake for fishing, boating, and swimming, and plentiful trails for horseback riding and hiking to mountain overlooks.

Travel became easier when the Norfolk and Western Railway began construction along the New River through Giles County to the Pocahontas coalfields in 1881. Visitors to Eggleston Springs Resort and Mountain Lake could disembark at Eggleston and Pembroke respectively to shorten the length of travel. Stops developed along the railway to serve the steam trains that frequently needed to take on water. The stops became depots with mail and telegraph service. Freight and passengers moved in and out of the stations, improving commerce and mobility.

Communities along the path of the railroad grew as trade became easier. Additional railways were built at the end of the 19th century that connected with the Norfolk and Western. The New River, Holston, and Western Railway, following Wolf Creek, and the Big Stony Railway, following Big Stony Creek, were both built to harvest timber in the previously sparsely populated areas. The Norfolk and Western rival Virginian Railway was completed on the eastern side of the New River in 1909.

Small communities farther from the railways were still self-sufficient but did not experience the growth of the places with easy access to trains for commerce and travel. Industries such as tanneries, limestone producers, Appalachian Power, and Celanese Corporation located in Giles County to utilize the natural resources. Water from the New River was used for manufacturing processes, the limestone cliffs along the river provided agricultural lime and lime for plaster, and the nearby railroad provided transportation for coal to power the industries and a way to ship the commodities produced. Many of the same industries remain today.

In the 200-plus years since Giles County was formed, countless changes have occurred. Many of the small communities of Giles County still exist, each with its own personality and flavor. The river and creeks, mountains, farmland, and forest create unique and, because of their locations off the main roads, often insular communities. Often a church and post office remain where businesses have closed. The larger towns have been greatly affected by the bypassing of U.S. 460, the ease of automobile travel, and population reductions due to changes in industry.

With 37 miles of the New River, over 92 square miles of Jefferson National Forest, and 50 miles of the Appalachian Trail, the mountains, rivers, and creeks have become tourist attractions with hikers, hunters, fishermen, boaters, and bikers from miles around partaking of the natural resources. Residents come together for Friday night high school football games, festivals, fairs, and craft shows. Pearisburg and Narrows residents are working to revitalize their communities and return businesses and people to their downtown areas. Giles County has always been a beautiful place with plenty of community spirit.

One

PEARISBURG
THE COUNTY SEAT

Though Giles County was formed in 1806, Pearisburg did not become the county seat until 1808, when George Pearis donated 53 acres to establish a town. A stone courthouse was soon completed, making Pearisburg a hub of business. People who visited the courts in the early days often stayed overnight because of difficult travel conditions. Court days were days for socializing, business deals, and entertainment, with many coming to town to watch the court proceedings, see old friends, and trade horses. Hotels were built to feed and house travelers. Stores were built, providing places to buy things that were not available locally or could not be made at home. The court remains in the brick building constructed in 1836, doing business as it has for more than 170 years. The widening of Route 460 bypassed the center of town, causing many businesses to close. Today, with the help of federal transportation enhancement funds, Pearisburg is revitalizing, with facade improvements, improved walkability, and an increased business base.

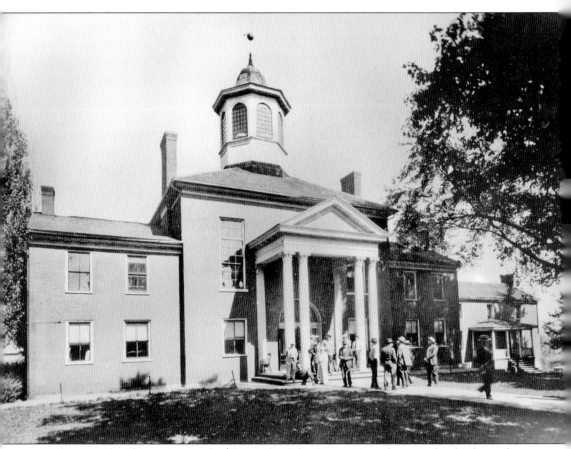

Built in 1836 by Thomas Mercer for $5,000, the Giles County Courthouse is the third courthouse and second courthouse building to stand in the public square since the county's founding in 1806. A Civil War skirmish that occurred here in May 1862 is said to have broken windows on the cupola and left bullet holes in the weather vane. The courthouse was renovated and rededicated during the county's bicentennial in 2006. (DLA.)

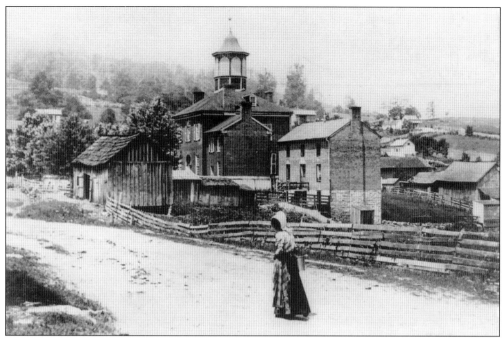

This classic photograph of Pearisburg shows an unidentified woman walking on today's Wenonah Avenue towards the courthouse. The windows of the cupola of the courthouse are said to be boarded up to cover the damage caused by the Battle of Pearisburg during the Civil War. Federal soldiers occupied the town for five days in 1862. The battle caused minimal damage and resulted in little loss of life. (GCHS.)

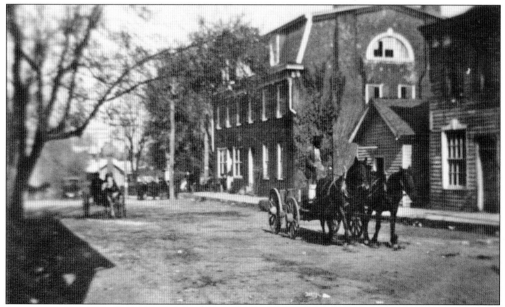

A view of Main Street in Pearisburg shows the Western Hotel, later known as the Thomas Building. The building was constructed by Guy D. French in 1827 of brick made on the public square in Pearisburg. The hotel had 16 large rooms, including a barroom and a ballroom. The building has been modified to create storefronts at the street level and apartments above. (GCHS.)

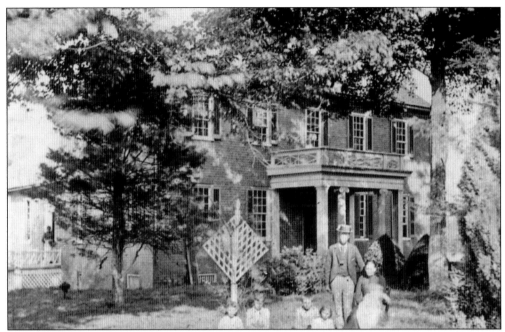

Built in 1829, the Andrew Johnston House in Pearisburg is the oldest surviving brick house in Giles County. Andrew and his brother, David, operated Pearisburg's first store, which was located near the courthouse. The house was continuously occupied by the Johnston family until the 1980s, when it was donated by Andrew's great-grandson, Fowler Johnston, to the Giles County Historical Society. The house has been restored and is open to the public today. (GCHS.)

Andrew Johnston's son, Harvey Green Johnston, was a doctor who began practicing in Pearisburg in 1853. The office was built in 1857 and used for five days in 1862 as a headquarters for Federal troops, including Col. Rutherford B. Hayes and Maj. William McKinley, future presidents of the United States. The doctor's son, Harvey Green Johnston II, practiced here until his death in 1945. Several other doctors practiced here later. The building is now owned by the Giles County Historical Society and is open to the public. (GCHS.)

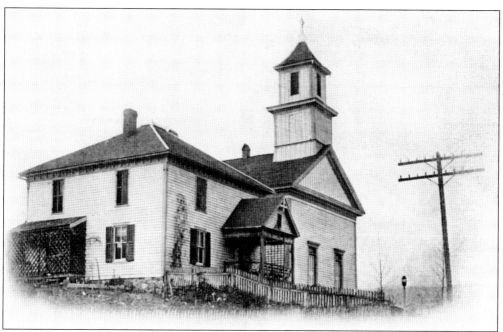

The Pearisburg Presbyterian Church was organized in 1850, with the first church building erected in 1861 across from the Johnston House on Main Street. The church was used as a commissary for five days in 1862 by Federal troops commanded by Col. Rutherford B. Hayes, then set on fire as the soldiers left town. Local women, forming a bucket brigade, extinguished the fire. The building shown was built in 1869, after the first church burned to the ground in 1867. (GCHS.)

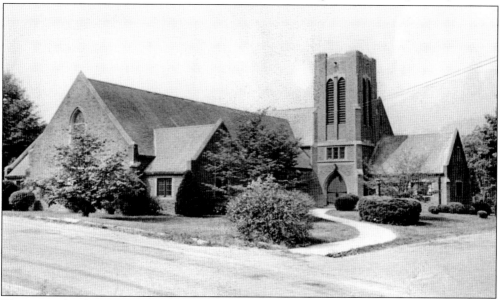

The current brick Pearisburg Presbyterian Church building, designed by Walter Raymond, replaced the old church in 1950. Members of the congregation donated money, time, and talents to build the new church. Located across town on Easley Street, the new church better accommodates the growing congregation's modern needs, such as Sunday school facilities. The sanctuary was consecrated in 1955. (GCHS.)

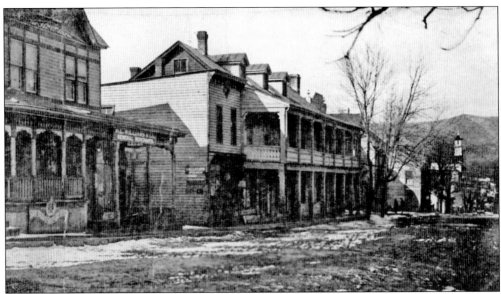

Pearisburg's Main Street is shown near the intersection with Wenonah Avenue in this early-1900s postcard. The Fount Johnston Building, containing the P. L. Williams and Company General Merchants store, is at left. Central Hotel is at center. The Presbyterian church steeple can be seen to the right. (GCHS.)

Porches were important social outlets in the days before air-conditioning and television. People sat on the porch to take advantage of summer breezes, but that also gave them the opportunity to visit with passersby. Socializing was the preferred way to pass time and catch up on family, friends, and gossip. (GCHS.)

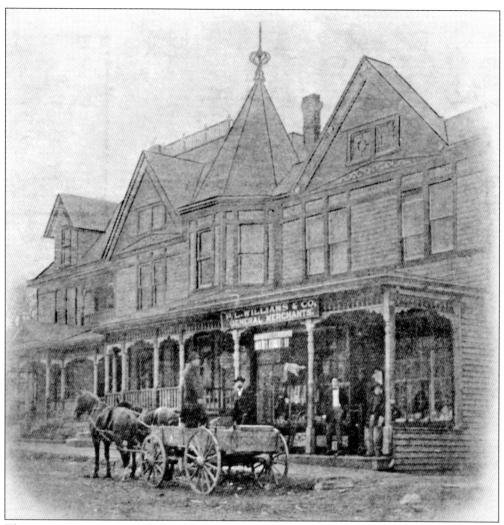

This structure was originally built by John W. Williams as a house and store building. Fount Johnston bought the buildings and additional land in 1902. Johnston constructed a hotel office, dining room, and four guest rooms to connect the buildings, creating the Savoy Hotel. Known as the Fount Johnston Building during his ownership, the building also housed P. L. Williams and Company General Merchants. (GCHS.)

The Witten family purchased the Savoy Hotel in 1912. Located south of the courthouse on Main Street, the hotel welcomed overnight guests, such as traveling salesmen, carnival people, work crews, lawyers, judges, and businessmen in need of lunch. The hotel closed in 1946 and was the Wittens' private home until 1965. (GCHS.)

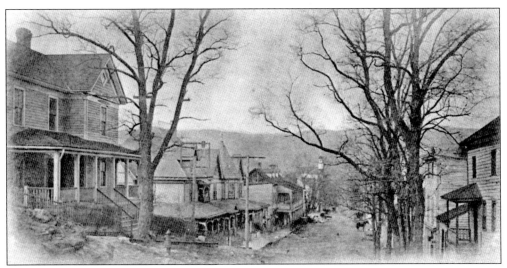

A postcard view of Main Street looking north towards the courthouse in the early 1900s shows a view very different from today. Houses and businesses lined the streets. Savoy Hotel and Central Hotel are on the left in the center of the photograph. The Presbyterian church steeple can be seen in the distance. (GCHS.)

This view of Main Street near its intersection with Mountain Lake Avenue shows the livery stable at left. When horses were the automobiles of the day, liveries provided a place to stable horses while people were in town on business or for residents to rent a horse to travel out of town. Raleigh Johnston's house and the Presbyterian church are to the right of the stable and across the street from the Andrew Johnston House. (GCHS.)

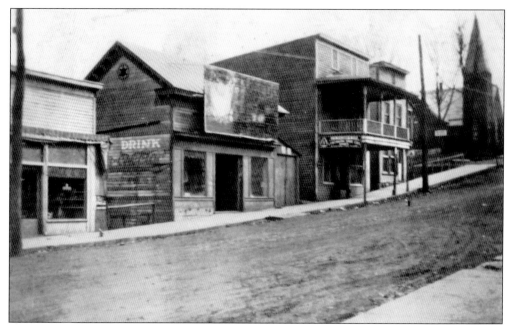

Main Street is shown heading south toward Dublin with (from left to right) J. W. Stafford's Barber Shop, Walker's Store, and Hall Electric. The old Pearisburg Methodist Church is shown at right at the top of the hill. Methodist churches used this site from 1847 until 1966, when a new church was built in the Sunnyside Acres section of town. The National Bank of Blacksburg now occupies this site. (GCHS.)

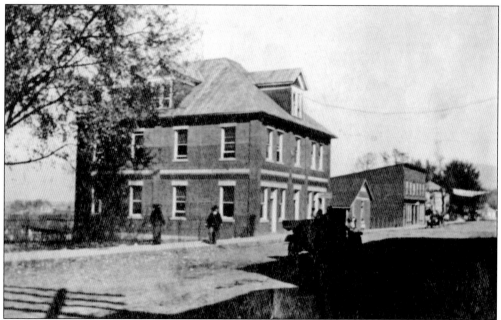

The law building was built on Wenonah Avenue in 1910 on the first subdivision of the public land that was originally reserved for the public square. The building provided office space for attorneys who practiced at the courthouse. Today it still houses offices, including the Virginia Cooperative Extension. (GCHS.)

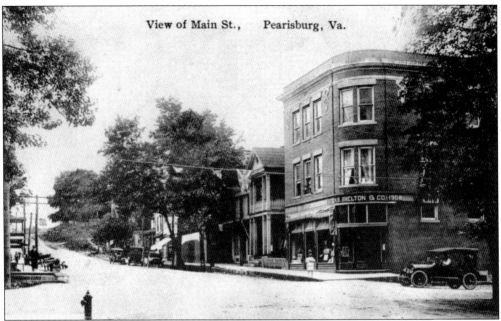

View of Main St., Pearisburg, Va.

A slightly later view of Main Street in Pearisburg shows the buildings across from the Western Hotel, which included H. B. Shelton's department store, established in 1908. The storekeeper, Harvey Bane Shelton, is shown at right in the 1880s. The store supplied fashionable clothes, shoes, and millinery to the women of Giles County and beyond for over 30 years. It later became a variety store and lost its third story to fire when the Woolwine house next door burned. Today it is a restaurant, and the building facade is being restored. Restoration uncovered the old painted store windows from the Cut Rate Drug store that once occupied the building. (Above, GCHS; right, DLA.)

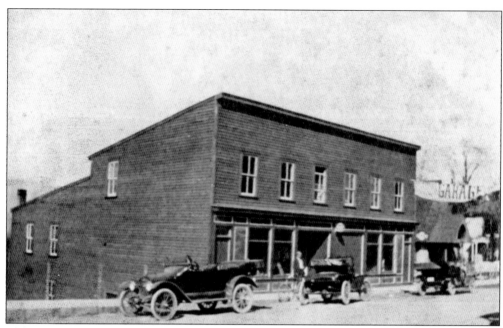

Blevins Garage is shown in the second decade of the 20th century next to Christ Episcopal Church. The garage was replaced by the 1930s. Christ Episcopal Church was established in 1907. The church building, built of river rock from the King farm and funded entirely by contributions from women, was completed in 1917 at the corner of Tazewell Street and Wenonah Avenue. The inside of the church was destroyed by fire in 1926, destroying many church records. The church was rebuilt in 1933, retaining the original river rock walls. (GCHS.)

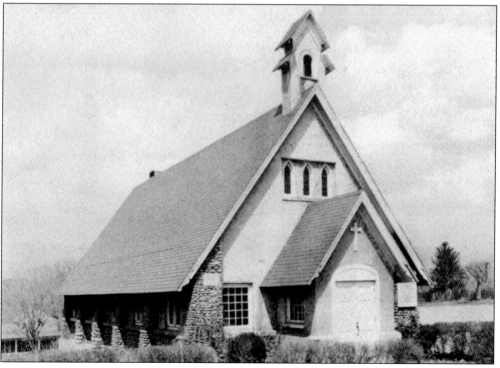

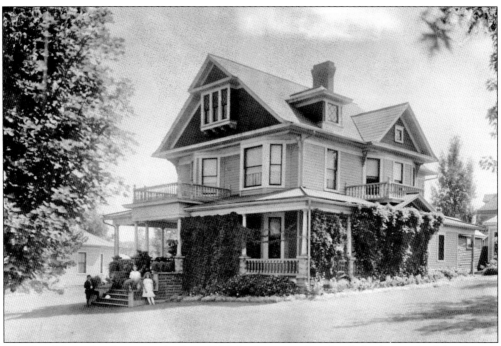

The Floyd E. Snidow house was built in 1906. Snidow served as the clerk of court for Giles County from 1907 until his death in 1956. The house was located where the BB&T Bank now operates on Wenonah Avenue. (GCHS.)

Directly across the street from the courthouse, at left in the photograph, is the First National Bank of Pearisburg on Main Street. Today the bank building has been transformed into the Bank Food and Drink gourmet restaurant. The Booth and Brotherton houses are undergoing renovation, and the buildings near the utility pole have been replaced by a RiteAid. (GCHS.)

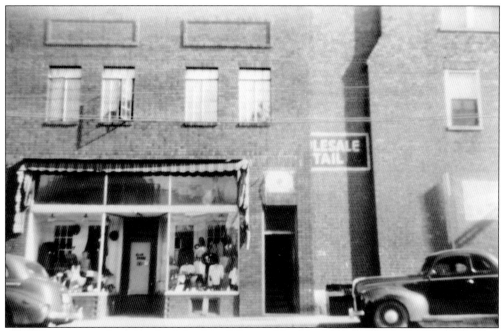

A clothing store is shown to the left of the Western Hotel building on Wenonah Avenue across from the courthouse in the 1940s. This two-story building was built in 1940 to replace the wing of the Western Hotel that had been removed in 1936. The second floor contains apartments that are connected to the hotel building by a hallway. New River Office Supply is located here today. (GCHS.)

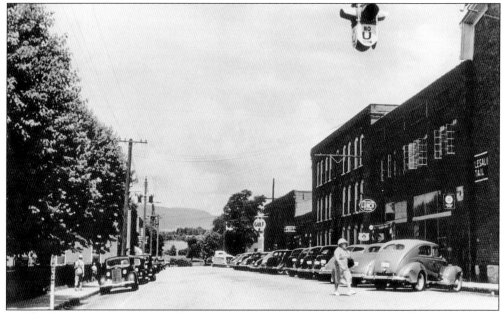

Wenonah Avenue in Pearisburg is shown from its intersection with Main Street. The courthouse is in the trees to the left. St. Elizabeth's Hospital, founded in 1924 by Dr. W. C. Caudill, is the three-story building on the right. The hospital was used until 1950, when a larger, more modern hospital was built. (DLA.)

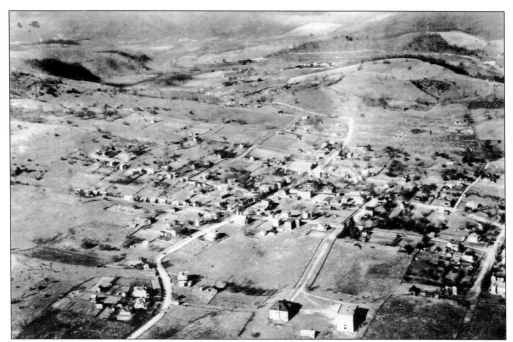

A pair of 1922 aerial views of Pearisburg shows the town bisected by Route 100 heading north (up) to Narrows and south to Dublin. The buildings in the top photograph at bottom center are Pearisburg Elementary and High Schools. At center in both photographs is the Main Street business district following Route 100. The courthouse can be seen at the Wenonah Avenue intersection. At the top right is the Johnston Brothers Apple Orchard, now the site of the Food Lion and Magic Mart plaza, with the New River located just beyond. Bluff City and the New River Tannery can be seen in the distance, to the left of the orchard. (GCHS.)

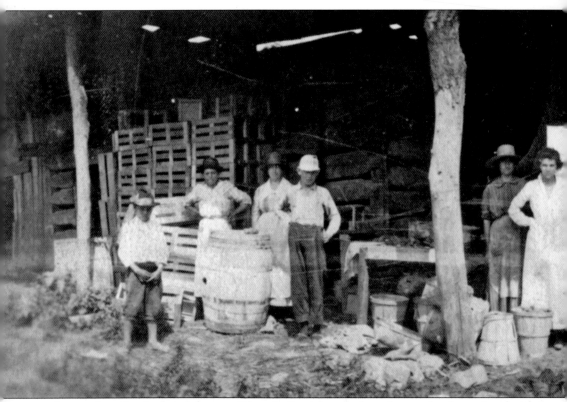

At one time, the Andrew Johnston House in Pearisburg had much more land associated with it than does today's property. When the house was built, the town of Pearisburg occupied several blocks around the courthouse. The Johnston house then was not in the town of Pearisburg but instead was located in the county. This makes more sense when the amount of land owned by

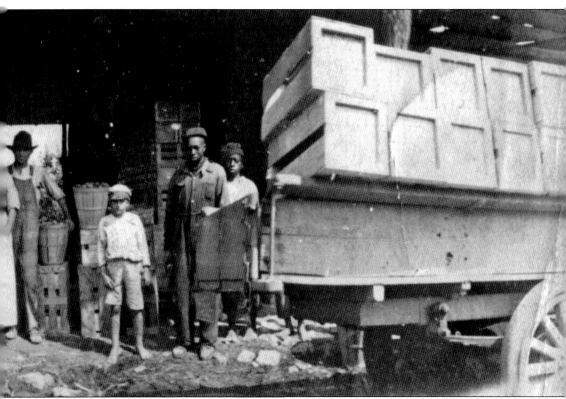

the Johnston family is considered. The Johnston Brothers Apple Orchard once had 5,000 trees covering the land beside the house where the Magic Mart and Food Lion plaza is now located. The packing shed is shown prior to Myra Johnston's death in 1922. Dr. Harvey Green Johnston II and his wife, Myra, are at center. (GCHS.)

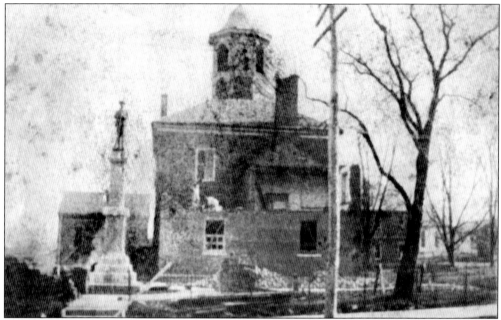

A boiler explosion demolished the west wing of the courthouse between 1909 and 1912. A number of changes were made to the courthouse in 1900, including the addition of the two-story front portico and a three-story rear addition. The many chimneys used to heat the building were removed when the boilers were added. The explosion required a near-complete restoration of the west wing. The Civil War Memorial is shown undamaged by the explosion. (GCHS.)

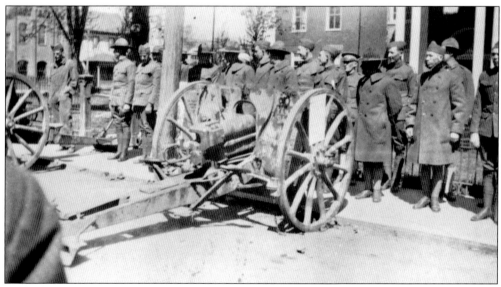

World War I soldiers and cannons are shown on the courthouse lawn. Over 400 men from Giles County fought in the war. Patriotism is high in the county, which has fielded soldiers in every war since the Revolution. The Veterans of Foreign Wars and American Legion are active in the community, as are chapters of the Sons and Daughters of the American Revolution (SAR and DAR) and the United Daughters of the Confederacy (UDC). (GCHS.)

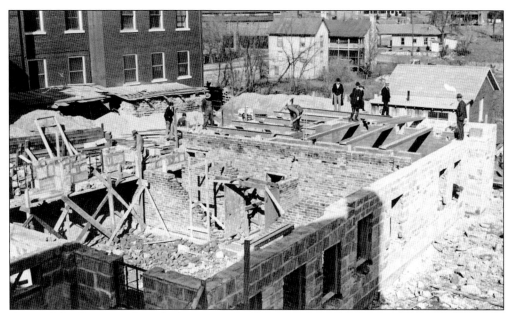

A new Giles County jail was built next to the courthouse in 1938. Here workers are placing the first steel girders. The jail was at the rear of the building with four cells per floor; the upper floor was the most tightly secured. Two cells in the basement were for female prisoners. An apartment at the front of the building was used as the sheriff's residence. (GCHS.)

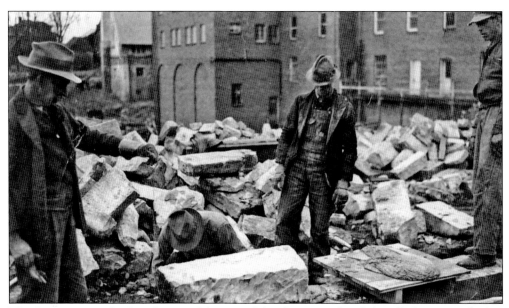

The first stone in the foundation of the new Giles County jail and sheriff's home was laid in the early part of 1938. Thomas Jesse Wood (left) laid the stone. William Morris is shown in the center. The jail closed in 1999, when it no longer met current standards. The sheriff's home is now used as the sheriff's office. (GCHS.)

The first post office was established as Giles Court House in 1811. The post office name was changed to Pearisburg in 1854. The name was changed to Pearisburgh in the 1880s before returning to Pearisburg in 1893. The post office is shown here in the Shumate Building, now Dr. Pippa Chapman's Chiropractic office. (GCHS.)

This gentleman is shown standing at Buchanan's store to the left of the Woolwine house on Main Street. He is a well-dressed man of the day, and his three-piece suit, high-neck collar, bow tie, and hat place this photograph in the early 1900s. (GCHS.)

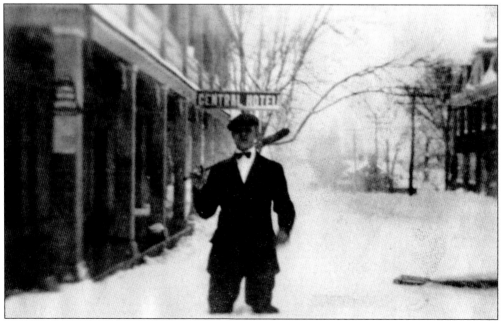

Winters can be difficult in Giles County. Snow reached a depth of 26 inches in a few hours near Christmas in 1913. Freezing weather in the winter of 1917–1918 caused the New River to freeze thick enough that cattle could be safely driven across. The temperature once dropped to 25 degrees below zero. Fortunately, the winters are not usually that cold or snowy today. (GCHS.)

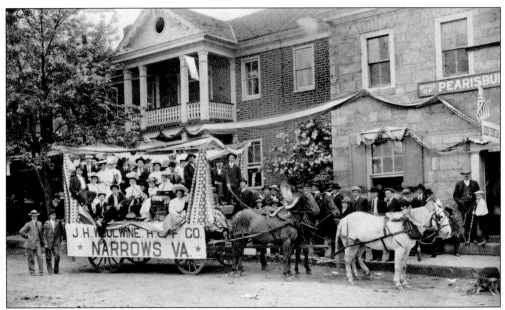

Giles County celebrated its centennial in 1906 with a parade. Shown here is J. H. Woolwine Hardware and Feed Company's entry in the parade. The group traveled the five miles from Narrows to be in the parade and is shown in front of the Woolwine house in Pearisburg. The stone building on the right contained the offices of the *Pearisburg Virginian* newspaper on the second floor and a soda fountain below. The building was replaced by the H. B. Shelton department store soon after this photograph was made. (GCHS.)

The Giles County sesquicentennial parade in 1956 is said to have lasted two hours and attracted thousands of people. The parade theme, celebrating Giles County's past and future, was "Her Health, Might, Industry, Youth and Beauty, and Recreation," with many floats, marching bands, and other participants. (GCHS.)

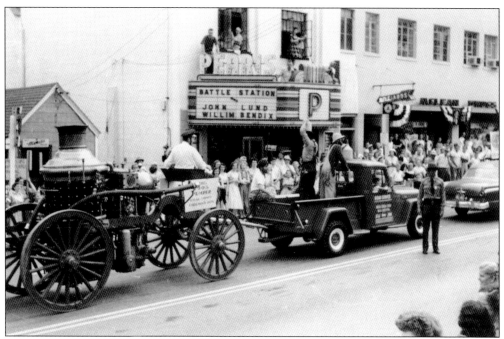

This photograph taken during the Giles County sesquicentennial parade in 1956 prominently shows the Pearis Theater marquee. The art deco theater, built by the Star Amusement Company, opened in 1939. Witten's Drug Store, with a soda fountain, was located next door. An evening out with family or a date could consist of a movie followed by a root beer float. (GCHS.)

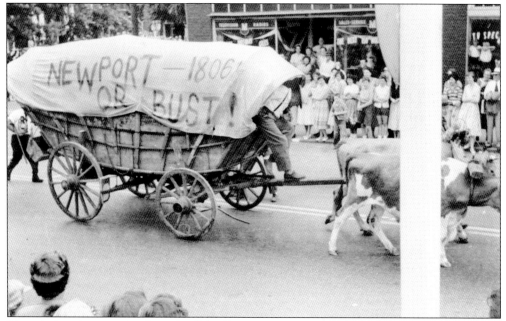

Though this photograph is from the Giles County sesquicentennial parade in 1956, it foretells the 1976 American bicentennial. One of the seven bicentennial wagon trains originating in Houston, Texas, visited Newport in 1976. The wagon train camped in the town park, where several shows were presented. An estimated 7,000 people visited the wagon train in Newport. (GCHS.)

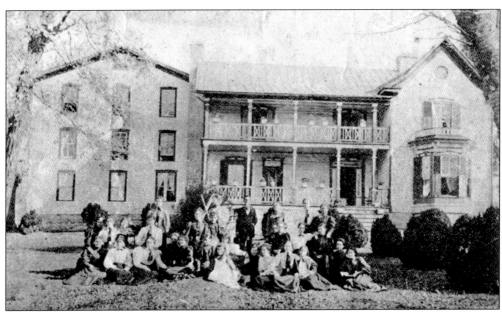

The Masonian Female Institute was established by D. W. Mason in 1893 one mile east of Pearisburg. The school had 8 to 10 teachers who were all college graduates and rooms for 30 boarding students when it closed in 1900. The institute is shown in 1896. (GCHS.)

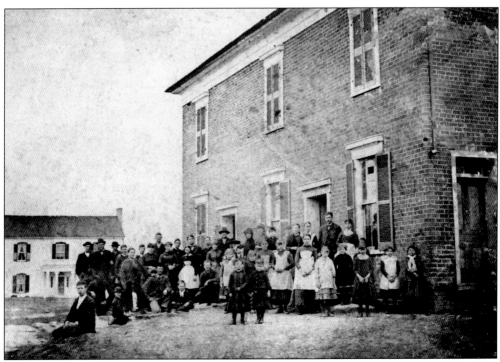

The brick Pearisburg Academy was built in 1839 with two classrooms on the first floor and a Masonic hall on the second floor. Students learned advanced mathematics, English, geography, and Latin. Several private schools were run here and in the Hoilman House, shown in the background. (GCHS.)

A new school, located near the current Pearisburg Baptist Church, was built in Pearisburg in 1908 at a cost of about $9,400. When this photograph was taken during the 1909–1910 school year, Jim Stafford was principal. The entire student body is shown. Grade school classrooms were on the first floor, and the high school was on the second. (GCHS.)

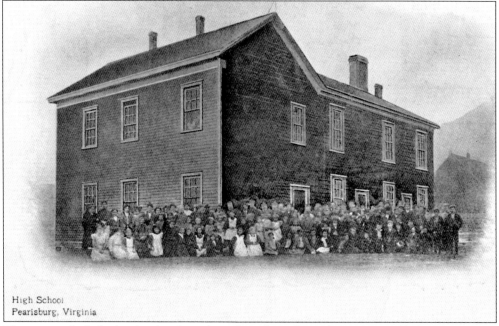

High School
Pearisburg, Virginia

This postcard of a high school in Pearisburg dates from the early 1900s. It is likely that it served children between the era of the Pearisburg Academy and the new high school built in 1908. With the exception of the private Masonian Female Institute and the Hoilman House, most of the school buildings in Pearisburg were made of brick. No information has been uncovered about this clapboarded high school building. (GCHS.)

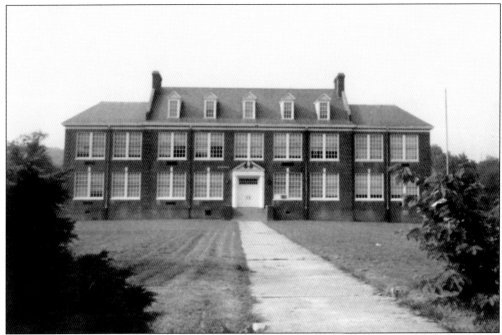

The King Johnston School was built using a WPA grant in 1939. The building served as Pearisburg High School until 1961, when Giles High School was completed, and as a middle school from 1961 until Macy McClaugherty Elementary School was expanded in 1980. Today the school serves as Pearisburg Community Center. (GCHS.)

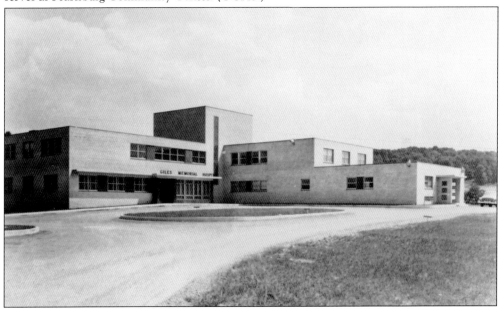

The 50-bed Giles Memorial Hospital began operation in 1950, replacing the 20-bed St. Elizabeth's Hospital founded in 1924 across the street from the courthouse. As the community has grown and medical technology has improved, the hospital has grown and changed. Today Carilion Giles Memorial Hospital is enlisting help from the community to build a new facility near the Pearisburg Wal-Mart. (GCHS.)

Two

COMMUNITIES

GILES COUNTY'S
MANY VARIED PLACES

Giles County's topography—the curving New River and its tributary creeks, high mountains, steep limestone cliffs, and rolling farmland—has naturally divided the land, creating a number of relatively isolated communities. Places with names like Narrows, Glen Lyn, Rich Creek, Pembroke, Eggleston, Staffordsville, Bane, Poplar Hill, White Gate, Kimballton, Ripplemead, Newport, Klotz, Goodwins Ferry, Wabash, Interior, Thessalia, Penvir, Trigg, Norcross, Maybrook, Lurich, Bluff City, Hoges Chapel, Curve, Clendenin, Goldbond, Midway, Shumate, and Clover Hollow were settled around natural resources, transportation corridors, and family connections, and each was self-sufficient in its own way. Today some of these places are incorporated towns, some are remembered with road signs, and others have disappeared without a trace.

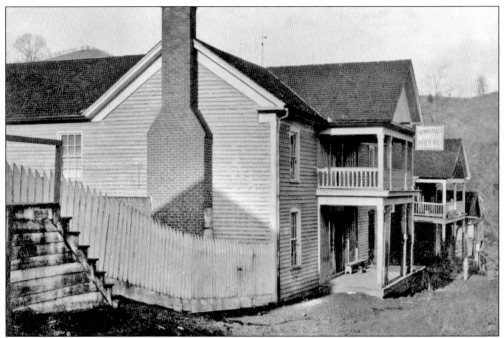

The Smith Hotel, shown here in 1880, was one of several in the crossroads village of Newport in the 1800s. The Fincastle-Cumberland Turnpike and Gap Mountain Turnpike once crossed here, creating a natural stopping point for travelers on horseback and stagecoach. Hotels provided food and shelter while stores provided trade opportunities. (DLA.)

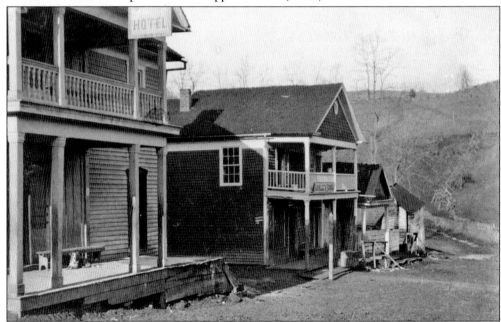

Dunklee and Echols Store is to the right in this photograph, with Smith Hotel to the left. When this photograph was taken in 1880, Newport had earned an unsavory reputation, along with the nickname "Hell's Half Acre," because of the number of saloons in town. Women were afraid to go to town on Saturday nights. (DLA.)

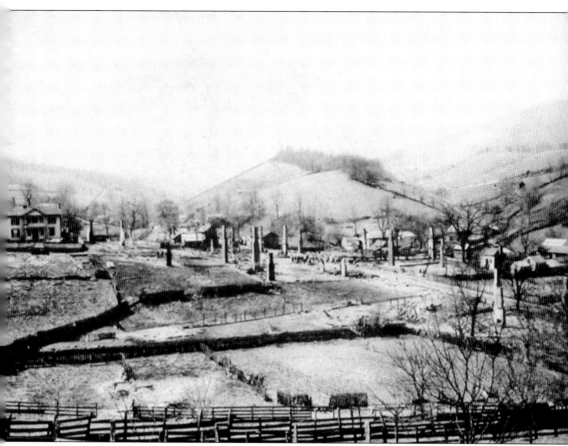

On April 1, 1902, the town of Newport burned to the ground. Lost were two hotels, five stores, the longhouse, the jail, two houses, and the Masonic hall. Smith Hotel and Dunklee and Martin Store were among the buildings lost. The fire was thought to have started from live coals in the rear of the Dunklee store and spread rapidly, fanned by the stiff mountain winds. Many, but not all, businesses quickly rebuilt. However, due to the fire, most of the buildings of Newport's downtown visible today are less than 100 years old. (DM.)

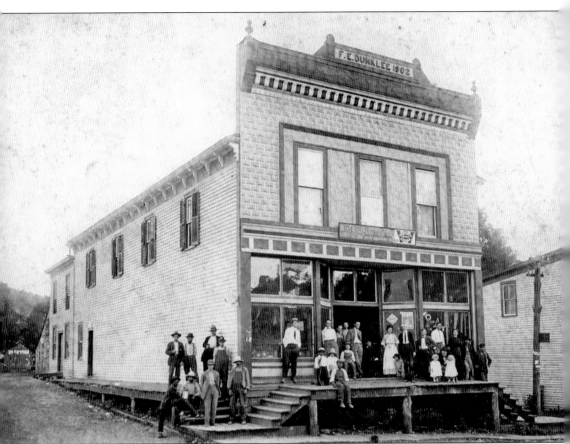

The F. E. Dunklee Store was built at the intersection of the Fincastle-Cumberland Turnpike and the Gap Mountain Turnpike in Newport in 1902, soon after the town fire. The Hunter House hotel, Miller Brothers General Merchandise Store, and a hardware store were among the other businesses rebuilt. Homes were rebuilt as well. Saloons and distilleries were soon voted out in the county to return order to Newport. (DM.)

Newport's first high school opened in 1912. The frame building had six classrooms and an auditorium that seated 200 people. Most children still attended one-room schools through the seventh grade unless their homes were located near the high school. A stable was provided for the horses and buggies used by the high school students to travel to school. The high school was replaced in 1933. (DM.)

A new brick school was built in Newport in 1933 by the WPA with 10 classrooms for elementary and high school students. High school students moved to Giles High School in 1961, leaving the elementary school students in Newport. Elementary students moved to Eastern Elementary School in 1982. Today the old school is used as the Newport Community Center. (DM.)

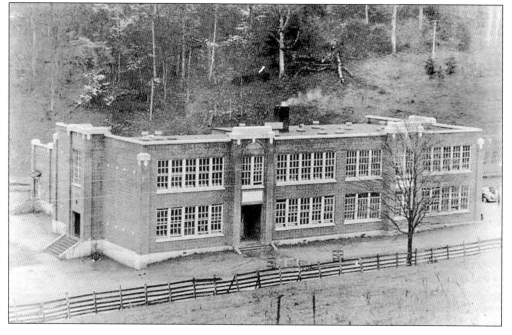

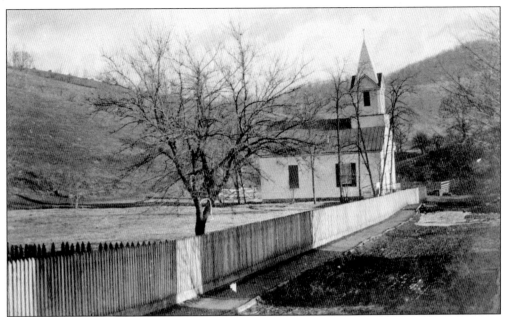

This church, shown in Newport in 1880, is typical of the many country churches of Giles County. Even the smallest of communities has at least one church, often white clapboard with a steeple. Most denominations are represented in the county, with Presbyterian and Lutheran churches representing the earliest Scots-Irish and German settlers. Methodist, Baptist, Christian, Mormon, and other churches were established later. (DLA.)

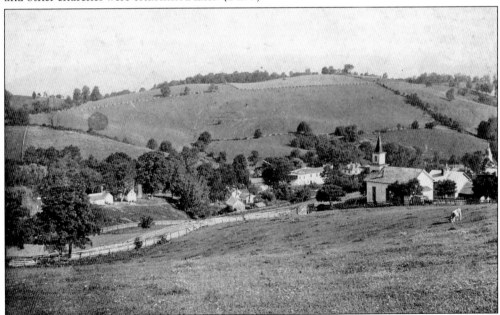

This view of Newport in the 1930s shows the quiet agricultural community that the town had become. Two gristmills and general merchandise stores remained in business, but many drove to Blacksburg, Christiansburg, or Roanoke for larger purchases. With little industry and few large landowners, most residents weathered the Depression on single-family farms, growing their own fruits and vegetables, eggs, and milk. (DM.)

The Sherry Memorial Christian Church is located on the road from Newport to Mountain Lake. The church, built in 1903, is a memorial to James Sheridan Porterfield, who was killed while working at a nearby sawmill in 1902. His grief-stricken father, L. F. Porterfield, donated the land for the building and completed the sanctuary a year later with help from friends and neighbors. (GCHS.)

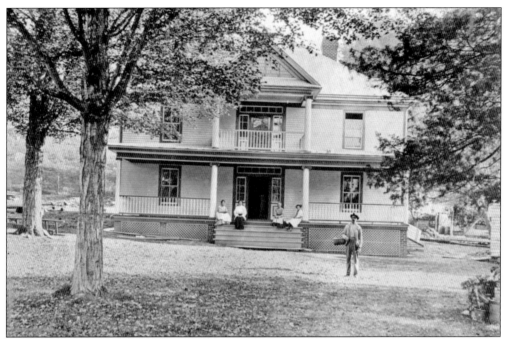

The Farrier home in Newport is shown *c.* 1912 with Henry Farrier, one-time superintendent of Giles County Schools, standing in the yard. The house was built in 1840. Due to its location along a main traveling route from Virginia to West Virginia, it was visited many times during the Civil War by troops of both sides in search of food and drink. (GCHS.)

The Lucas Memorial Christian Church, shown in 1951, was established in Maybrook by Dr. Chester Bullard in 1833. Dr. Bullard influenced five other churches in Giles County and was known for preaching from the cliffs high above the river in Eggleston. His booming voice reached the congregation on the opposite river bank and led to the rock formation being known as Bullard's Rock. A new church building was completed in 1961. (DLA-NS.)

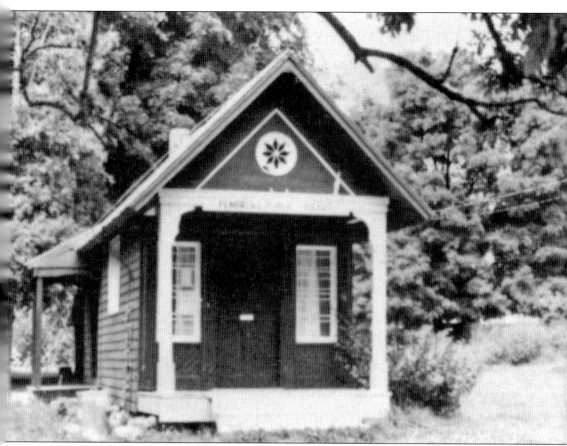

Pembroke was first settled by Phillip Lybrook in the mid-1750s along the New River. Lybrook was joined in the 1760s by the Snidow family, who later operated a ferry across the New River. The community was named in 1845 by postmaster John Lybrook, who was reading a book, possibly Shakespeare's *Sonnets*, found the name Pembroke, and named the town. Pembroke is today a town of over 1,100 people and has the distinction of having the smallest library in Virginia. The library is located in this small frame building that was once an old stagecoach stop and post office. (GCHS.)

Pembroke's sixth school was built in 1925. The brick school had 13 classrooms, a large auditorium, and a library. High school students moved to the new Giles High School with Pearisburg, Newport, and Eggleston students in 1961. Elementary school students moved to Eastern Elementary School with its opening in 1982. The school has since become S. A. Robinson Apartments for low-income senior citizens; its classrooms now hold 27 apartments, laundry and kitchen facilities, and a community room. (GCHS.)

Eggleston's first consolidated high school, opened in 1921, brought together students from the communities of Berton, Bearspring, Rye Hollow, Green Valley, Mountain View, Goodwin's Ferry, Wingo, and Eggleston. The building shown here opened in 1934. High school students moved in 1961 with the opening of Giles High School. Elementary students stayed until 1982, when Eastern Elementary School opened. The school was used by the Samax sewing company for several years and is currently vacant. (GCHS.)

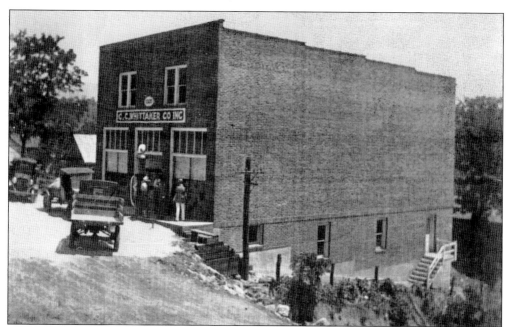

The C. C. Whittaker Company, Inc., store is shown in 1926 soon after it opened as the first brick store in Eggleston. The store sold gasoline as well as general merchandise and was at one time one of six stores in Eggleston. Becoming Pyne's store in 1945, it remained in business until the 2000 passing of Gladys Dowdy, who, with her parents and sister Erma McPeak, had run the store for 60 years. (EW.)

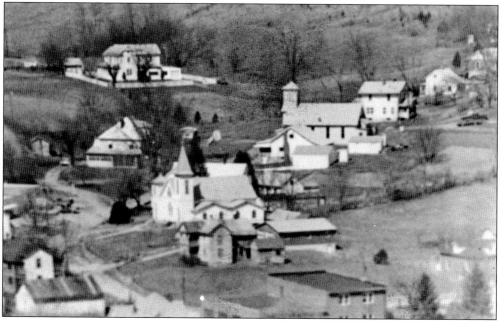

While it was once a bustling shipping point, today the hotel, school, and most businesses in Eggleston are gone. Churches and homes are visible in this 1980 photograph of the town center. With a population of about 300, fishing and camping on the New River are still a draw for tourists today. (GCHS.)

Staffordsville was settled by Irish immigrant Ralph Stafford in the late 1700s on the banks of Walker's Creek. The creek provided power for the sawmill, shown in 1880, and other industries, including a gristmill, a tannery, and a cotton mill. (DLA.)

The hills and creeks of the area made town settlement difficult. A map of Staffordsville filed at the courthouse in the 1800s shows 17 lots, including a blacksmith shop, general store, gristmill, sawmill, tannery, post office, newspaper, cotton mill, two churches, and one doctor. This 1880 view shows the challenges of Staffordsville's topography. (DLA.)

W. K. Brooks and Company Store is shown to the left in this 1880 photograph of Staffordsville. William Kirk Brooks was the first store owner in Staffordsville and partnered for many years with his first cousin Charles Brown. Brown was the postmaster from 1875 until 1909. Brooks and Brown died in 1912 and 1911, respectively. (DLA.)

The four-room Bane Elementary School was built in 1952 with a student capacity of 115. The school replaced an earlier frame structure with two classrooms that was in disrepair by 1948. The school was occupied by the Giles County Positive Approach to School (PATS) alternative program, after Bane Elementary School was consolidated with others in the county in the 1980s. (GCHS.)

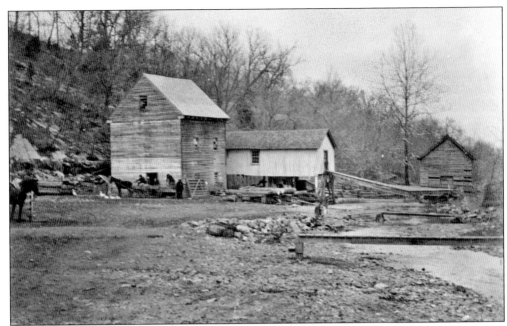

The mill shown here in 1880 was on Mill Branch of Walker's Creek in Wabash. Wabash was named by a family who was headed to Wabash, Indiana. When their wagon broke down in Giles County, they decided to stay. Nineteenth-century businesses included three stores, three mills, two blacksmith shops, an iron foundry, a casket shop, a tollgate, a post office, three hotels, a harness shop, a doctor, and the Wabash Academy. (DLA.)

The Wabash Academy, built prior to the Civil War, is said to have been the first two-room school in Giles County. The academy was built on the Pulaski-Giles Turnpike, a toll road connecting Narrows and the Giles County courthouse in Pearisburg to Newbern in Pulaski County and the Wilderness Road. The largest spring in the county is located nearby. (GCHS.)

The Wabash Camp Meeting began in 1834, attracting many Methodist preachers and hundreds of parishioners for a week each summer until 1896. Itinerant preacher Robert Sheffey evangelized there as well as throughout Southwest Virginia. The power of Sheffey's prayers became legend, with stories of healing and other miracles. Though Sheffey died in 1902, the Sheffey Memorial Camp Meeting was organized in 1979 and has met in Trigg every July since. (GCHS.)

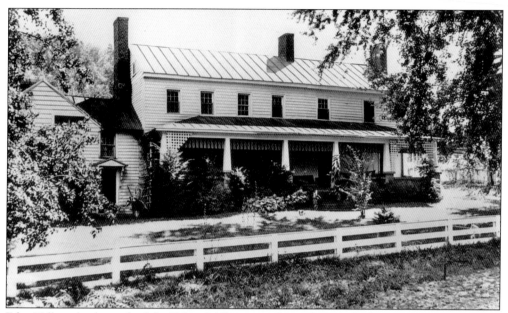

Edge Hill is a log house built by Tobias Miller one mile southwest of White Gate in 1826. Before the Civil War battle of Cloyd's Mountain, Union general W. W. Averill raided this part of the county. It is said that his troops went to the attic of the Miller house, poured tar on the floor, mixed it with pillow and bed tick feathers, and tracked the mess throughout the house before leaving. (DLA.)

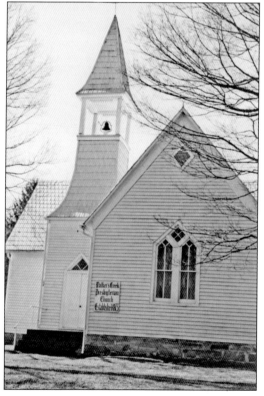

Walker's Creek Presbyterian Church was established in White Gate in 1873 by 11 women and 2 men who had previously traveled to neighboring counties to attend church. The original brick church had been outgrown by the 1890s, when this Gothic Revival–style church building was constructed by local builder George L. Bane with help from the congregation. With a remaining congregation of just nine people, the church closed in 2003 and has been placed on the National Register of Historic Places. (GCHS.)

In the background is the Clay Mason home in Ripplemead. Mason's father, D. W. Mason, founded the Masonian Female Institute in Pearisburg. Clay Mason owned the Virginian Lime Plant in the 1930s. Ripplemead was named for the rippling waters of the New River and the meadows or meads. (GCHS.)

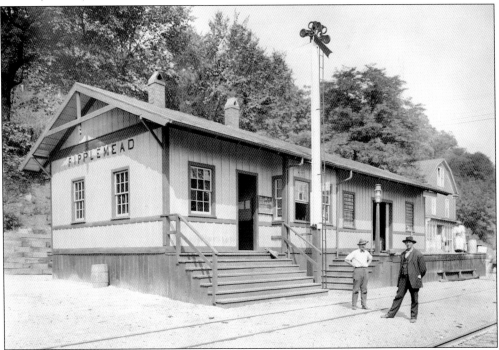

The train station was once the center of activity in Ripplemead. A ferry across the New River and a store, post office, church, barrel shop, and several other buildings made up the village. The Poor Farm and two one-room schoolhouses were located nearby. Though it was once a transportation hub, Ripplemead was totally bypassed when U.S. 460 was expanded to four lanes. (DLA-NS.)

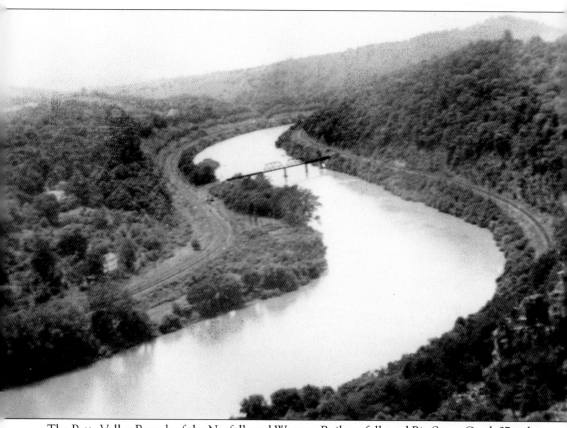

The Potts Valley Branch of the Norfolk and Western Railway followed Big Stony Creek 37 miles from Norcross to Paint Bank from 1892 until the 1930s. Stops along the railroad included Kimballton, Kerns, Interior, Kire, Ray Siding, Waiteville, and Laurel Branch. The bridge shown connected the Norfolk and Western Railway near Ripplemead with Norcross across the New River. (GCHS.)

Interior, a timber town on the Big Stony Railway, has mostly disappeared into history. A historic marker in the Jefferson National Forest on Route 635 marks the location where the community once stood. Timber was harvested from the time the train reached Interior in 1896 until the 1920s, when all of the trees had been cut. (GCHS.)

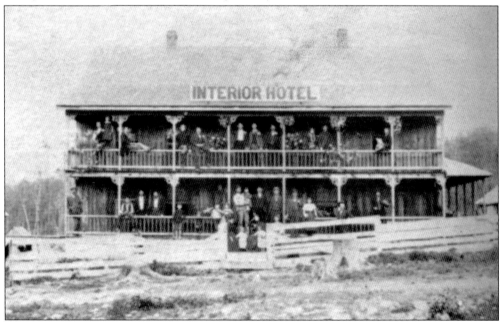

A hotel was built at Interior by an out-of-state lumber company to house the employees of its local sawmill. Until 1908, when the Big Stony Railroad was extended to Paint Bank, Interior Hotel was located near the end of the railroad. After the railroad tracks were removed in the 1930s, Interior became little more than a name on a map. (GCHS.)

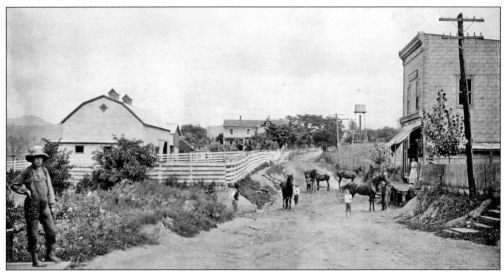

The road east through Bluff City led to the New River Tannery. The Thomas farm, Thomas home, and Thomas Mercantile Company store are shown from left to right in this 1909 photograph. W. H. Thomas is standing just below the corner of the fence, while his wife is standing on the store porch. (GCHS.)

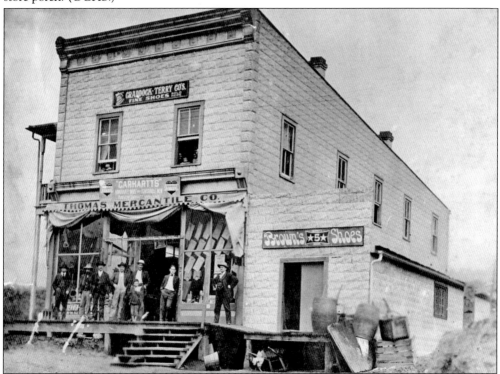

This photograph of the Thomas Mercantile Company store in Bluff City was taken around 1906. Advertisements show Carhartt ("honorably made for honorable men"), makers of sturdy work clothing still in business today; Craddock-Terry Company's Fine Shoes, made in Lynchburg, Virginia; and Brown's Shoes, makers of Buster Brown shoes. The store served New River Tannery workers living nearby. Thomas operated the Bluff City store until his death in 1939. (GCHS.)

The William Henry Thomas home in Bluff City is shown in 1909. Thomas's wife, Orrie Olivia Dills Thomas, sits on the porch, while the children, from left to right, Wanda, Bill, and Mary Sue, are shown with the pony and carriage. W. H. Thomas established many businesses, including Thomas Mercantile Company in Bluff City as well as Chevrolet and Dodge dealerships, a grocery, a hardware store, and a men's haberdashery in the Western Hotel building in Pearisburg. (GCHS.)

Josephine Walker, holding Douglass Ratcliff, is pictured in front of the Bluff City School in the 1930s. The ladies in the background are Polly Walker (left) and Mrs. Hambrick. Before desegregation, Bluff City had both black and white schools. The community was called Free State after the Civil War for the black residents who lived there. (GCHS.)

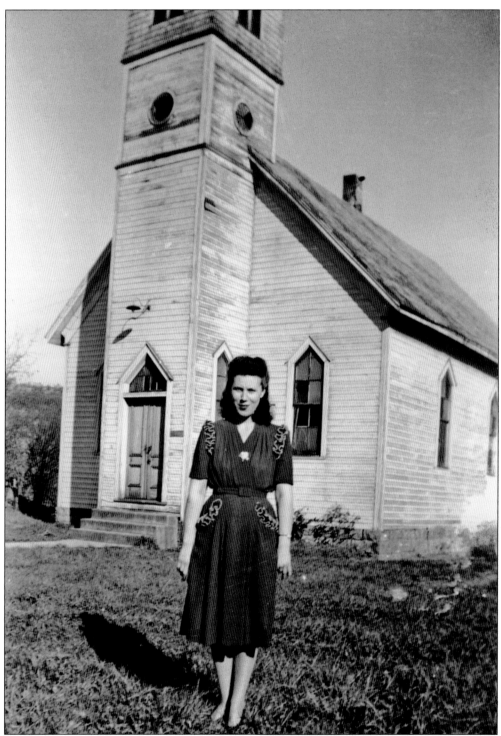

Mrs. Lewis "Toosie" Ratcliff is shown in front of Bluff City Methodist Episcopal Church South in 1904. The church was established in 1895, later becoming a United Methodist church. The building was used by other denominations as well before it closed in 1976. (GCHS.)

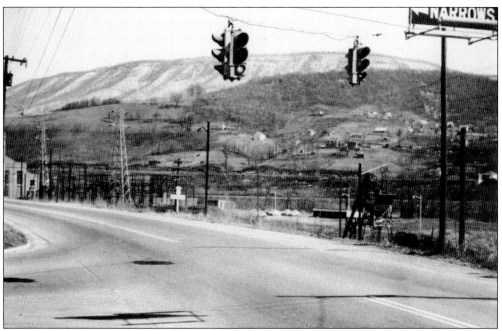

Narrows has the distinction of having the only traffic light on the 50 miles of U.S. 460 between Blacksburg and Princeton, West Virginia. To the left is the Virginian Power Plant and the power grid needed to electrify the Virginian Railway. The mountain view is typical of Giles County, where snow can often be seen on the mountain tops even when it does not reach the towns. (CGT.)

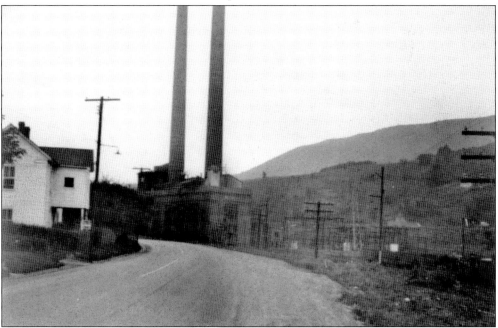

This view shows U.S. 460, or Virginia Avenue, in Narrows just east of the previous photograph, with a better view of the Virginian Power Plant. The road was widened to four lanes in 1972 after the power plant was demolished. Portions of the new highway were constructed on the old Virginian Railway right-of-way. (CGT.)

The town of Narrows is located on both sides of the New River. The eastern side of the New River along U.S. 460, shown in 1942, grew when Celanese Corporation built a plant nearby. This area is mostly commercial today, though some houses and the old road can still be seen. To reach the downtown area, visitors cross Memorial Bridge from U.S. 460. (CGT.)

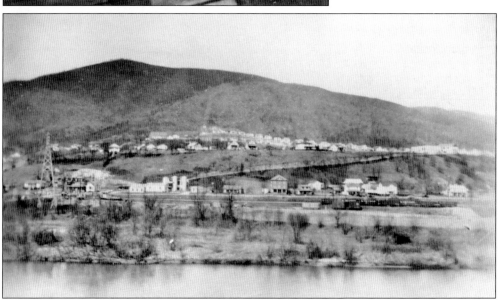

The view across the New River from downtown Narrows shows the eastern side of the river along U.S. 460. The hill in the background was being developed with houses for the new Celanese Corporation plant when this photograph was made in the 1940s. A new Narrows High School was built in 1961 in the same area. (CGT.)

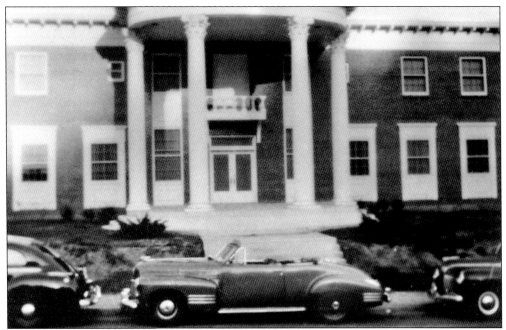

The Hotel General MacArthur is shown in 1942, the year the hotel opened for business in Narrows. The hotel was built to accommodate business travelers to the new Celanese Corporation plant nearby. The hotel was initially quite popular and served as a social center for the county; however, the hotel had closed by 1956. The building was used as Riverview Nursing Home and an assisted living facility from the 1960s through the 1990s, then as apartments. Today the hotel is being renovated for use once again. (CGT.)

This 1950s view up Main Street in downtown Narrows shows the café that stood at the corner of Main and Monroe Streets. The café building shown in the left of the photograph and two other old buildings were removed in 2001 to realign and widen Monroe Street during downtown revitalization. Main and Monroe Streets in the downtown area received new sidewalks and lighting during the construction, which was completed in 2002. (CGT.)

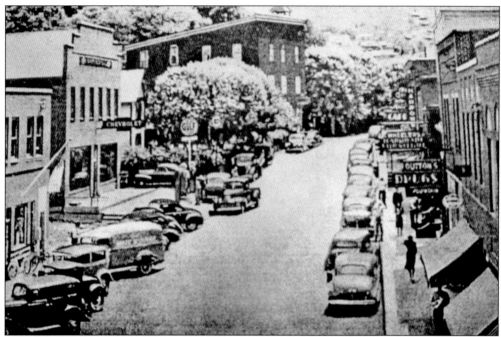

The Main Street business district in Narrows is bustling in 1941. Some of the businesses visible in the photograph are Dutton's Drug Store and soda fountain, Wheeler's Hardware, Wheeler's Furniture, Narrows Café, and Narrows Motor Company. The three-story building in the center of the photograph is the Odd Fellows Hall and Masonic Lodge. Narrows Post Office was built on the site in 1963. (NCC.)

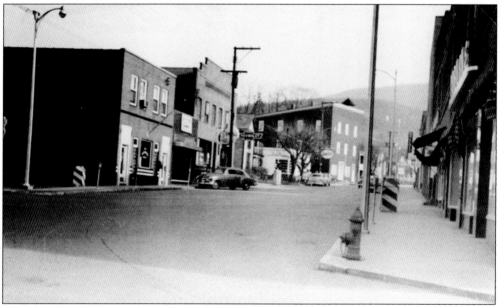

This view from Monroe Street near where Anna's Restaurant is now shows the east side of Main Street in the 1950s. People came from the outlying communities to shop and do business in the commercial district. Today there are just as many empty storefronts as there are businesses, forcing people to do their shopping elsewhere. (CGT.)

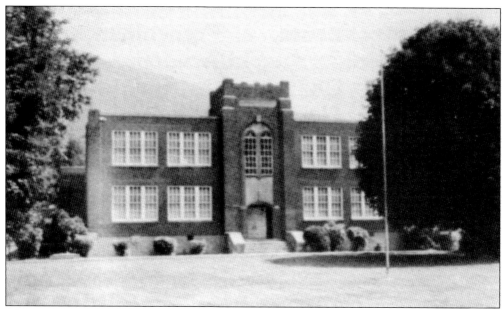

The old Narrows High School, facing Monroe Street, opened in 1931. By 1961, the school had become overcrowded due to population growth in the town, and a new Narrows High School was built across the New River. One of two high schools in the county, Narrows High School serves students from Narrows, Rich Creek, Glen Lyn, and Wolf Creek. After closing, the school was used as the Narrows Elementary School Annex until 1987. Today the building is a community center. (GCHS.)

Though a new high school has been built, the Narrows High School football team continues to play at Ragsdale Field at the old high school. The field is shown in 1942, not long after the New River, Holston, and Western Railroad tracks connecting Memorial Boulevard to Wolf Creek had been removed. During gym class, students removed earth to flatten the area that would become the football field and a place for bleachers. (CGT.)

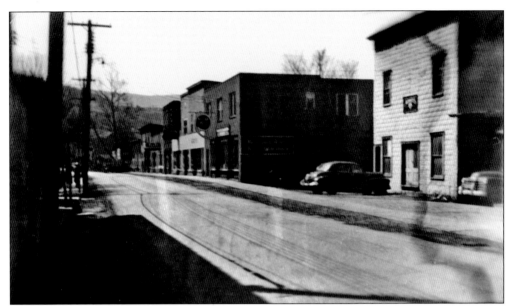

Monroe Street is shown in the 1950s headed west toward the Duck Pond and old high school in Narrows. Wolf Creek is behind these businesses, which were prone to flooding. A milldam at the far end of the street creates today's Duck Pond, once known as the Mill Pond. The first dam was built before the Civil War to power a gristmill. Gristmills remained there until the Kingrea mill was removed in 1964. (CGT.)

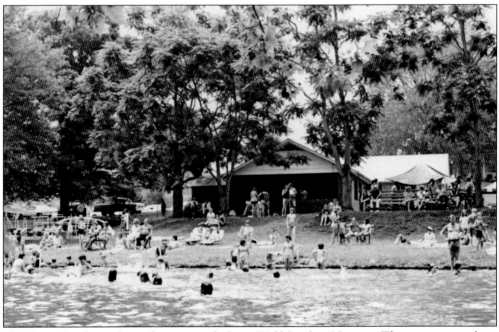

The "Boom" is the traditional swimming hole on Wolf Creek in Narrows. The name comes from the sound made by logs floated by loggers down Wolf Creek to the Mill Pond below. As the logs hit each other in the Mill Pond, they made a loud booming sound, which was magnified in today's swimming area. The park has been owned by the town since 1950 and includes picnic shelters, basketball courts, and a playground. (GCHS.)

62

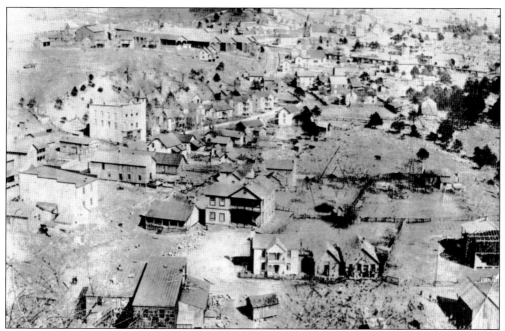

Narrows is shown in 1903, one year before becoming an incorporated town. The view is across Wolf Creek. The Odd Fellows Hall is the three-story building on Main Street shown at middle left. On the hill at the top of the photograph is Snowflake Tannery, operating from 1896 until 1930. The tannery employed about 100 men to meet the growing demand for leather. (GCHS.)

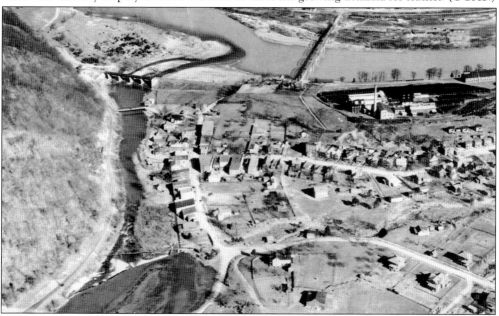

Main Street crosses horizontally in the middle of this 1920 aerial photograph of Narrows. Monroe Street connects with Main Street vertically near Wolf Creek to the left. The creek flows into the New River, which narrows here, giving the town its name. Also visible are the Snowflake Tannery to the right and the two stacks of the Virginian Power Plant across the river to the right of the bridge. (GCHS.)

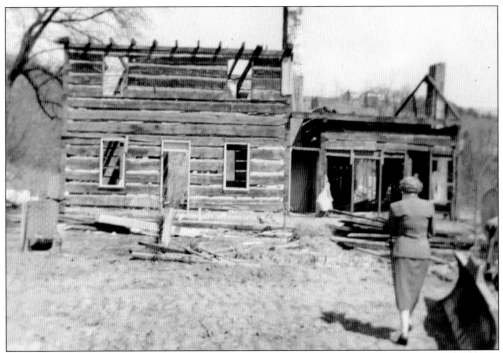

Daniel Shumate built this log home in the center of Rich Creek in the 1780s. As the first settler of Rich Creek, Shumate received 300 acres by land grant from Edmund Randolph, governor of Virginia. The acreage included all of what is now Rich Creek. Daniel Shumate's home has since been demolished—note the bulldozer in lower right of photograph. (RCPL.)

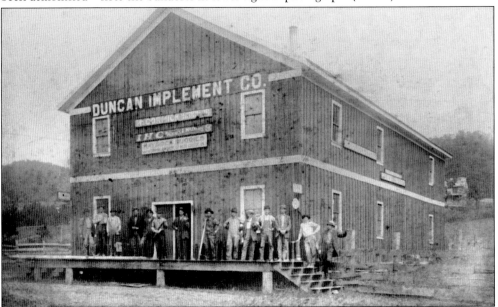

Duncan Implement Company in Rich Creek is shown in 1939. The company began in 1912 and was run by John H. Duncan and his son, Clarence. The store sold everything from tools to fertilizer. Signs on the building advertise McCormick and International Harvester machines and implements and Haycock Buggies. (RCPL.)

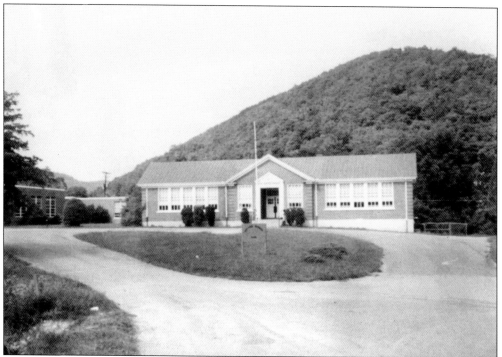

Rich Creek's school was built in 1936 with four rooms and a capacity of 120 students. Two additions added six classrooms and increased the capacity to 270 students. High school students had long attended Narrows High School, but elementary students attended Rich Creek's school until moving to Narrows Elementary/Middle School in 1990. The old school is now the Rich Creek Community Center, including town offices, a library, and a recreation center. (GCHS.)

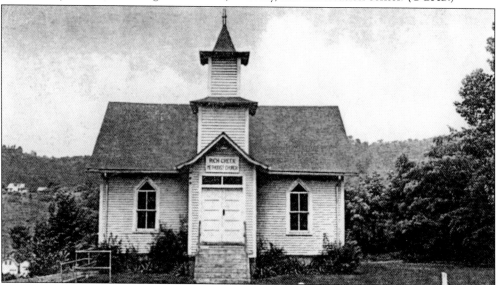

The Rich Creek Methodist Church was organized in 1916 in a one-room schoolhouse. Services were held once a month, with Sunday school every week. The building shown was constructed in the 1920s. Church membership continued to grow, so a new educational building was constructed in 1956, followed by a new sanctuary in 1961. (RCPL.)

From left to right, Edgar Lee Spangler, his wife Julia, and sons Oran "Togo" and Otis are shown at their home, known as the Mercer Angler Club. Edgar Spangler was the first mayor of Rich Creek when the town was incorporated in 1946. Togo Spangler was the owner of the airplane Texaco station. (RCPL.)

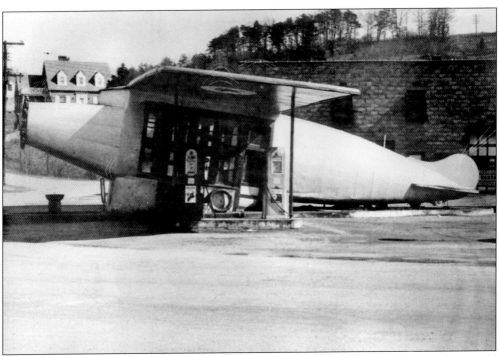

Togo Spangler built the airplane Texaco at Rich Creek in 1924 with the idea that travelers would be attracted by the unique station and buy gas while they were there. The office and restrooms were located in the body of the airplane. The propeller turned constantly. The station was located where Routes 219 and old 460 met until 1954, when a tractor trailer damaged one of the wings. (GCHS.)

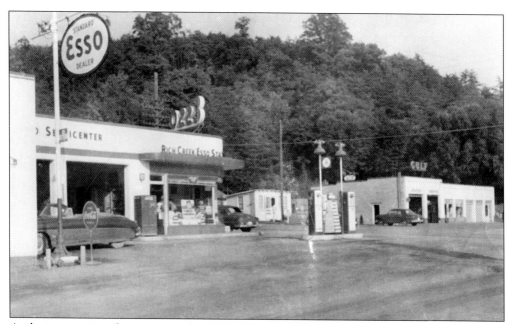

At the intersection of two main roads—U.S. 460 west to Bluefield and U.S. 219 north to Lewisburg, West Virginia—Rich Creek is a prime location for service stations such as the airplane Texaco and the Esso and Gulf stations shown here in 1951. The Esso station was once the location of a grocery store, while a hardware and harness business and later a concrete block plant occupied the site of the Gulf station. (RCPL.)

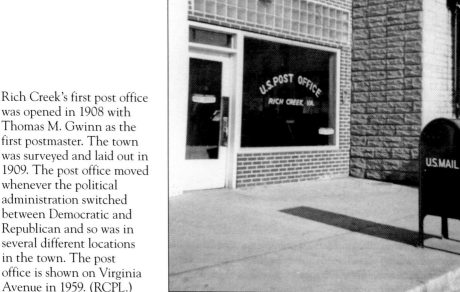

Rich Creek's first post office was opened in 1908 with Thomas M. Gwinn as the first postmaster. The town was surveyed and laid out in 1909. The post office moved whenever the political administration switched between Democratic and Republican and so was in several different locations in the town. The post office is shown on Virginia Avenue in 1959. (RCPL.)

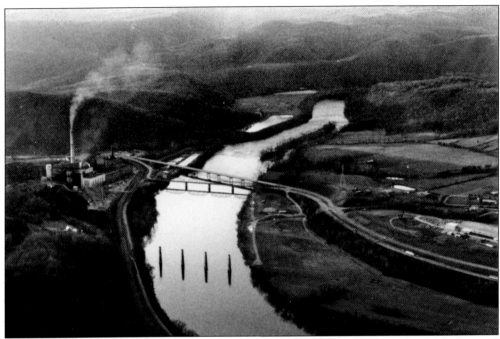

This aerial view shows the Appalachian Power plant at Glen Lyn to the left. In the foreground are the concrete piers for the old Virginian Railway bridge to the power plant. Route 460 was made into four lanes, with a new westbound bridge built in 1969. The old bridge, built in 1930 and visible in this photograph, was still used for the eastbound lanes until it was replaced in 1986. (GCHS.)

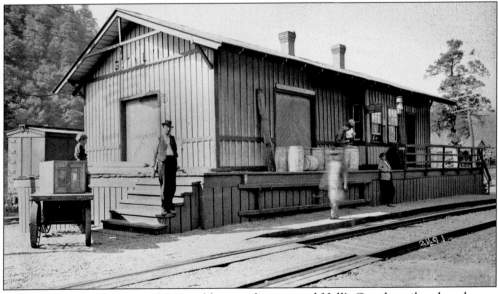

Glen Lyn was first known as Montreal but was later named Hell's Gate by railroad workmen, probably due to the difficulty of laying track through the mountainous and rocky terrain. When the Norfolk and Western Railway was completed in 1883, the name became Glen Lyn for lovely glen. Glen Lyn is the smallest incorporated town in Giles County with 163 people in 2005. (DLA-NS.)

Three

TRANSPORTATION
GETTING FROM HERE TO THERE

Between the mountains and the river and creek crossings, transportation has always been a challenge in Giles County. Stagecoaches passed on rutted roads, carrying tourists to Eggleston Springs and Mountain Lake resorts and further to the springs resorts of West Virginia. Rivers and creeks were forded where the water was low. Ferries were in place at many crossings, some well into the 1940s. Impressive bridges were built to make the New River crossings, some of which have been destroyed by floods throughout the years. Railroads made transportation easier for both people and freight. Following the banks of the New River, Big Stony Creek, and Wolf Creek, railroads such as the Norfolk and Western, Virginian, Potts Valley, and New River, Holston, and Western were able to avoid many mountain crossings to move coal, timber, and passengers through the county. Roads improved throughout time as well, with the main routes—460 (east and west) and 100 (north and south)—now mostly four lanes. Improvements in transportation have not come without a cost, however. Improved roads have meant bypassing communities, many of which have lost the downtown businesses they once had. Norfolk Southern is the only remaining railway, using Norfolk and Western and Virginian Railway tracks on both sides of the New River to haul coal and other commodities but no passenger traffic.

From the early 1800s, the road to Mountain Lake Hotel had been a well-traveled route to what is now West Virginia. Stagecoaches braved the narrow, rutted roads to deliver passengers to the springs resorts, where they improved their health. During the Civil War, the road was used by Federal troops retreating to Unionist West Virginia. Legend says munitions, including a brass cannon, were dropped over the mountain by troops trying to lighten their load. (DLA.)

Giles County is networked with rivers and creeks that often pose a problem to transportation. It was not always practical to build a bridge or a ferry when this photograph was made in 1880. If the water was low, the creek could be forded by horse and wagon, as this farmer is doing. (DLA.)

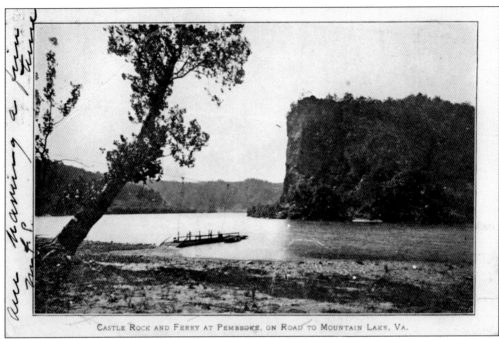

CASTLE ROCK AND FERRY AT PEMBROKE, ON ROAD TO MOUNTAIN LAKE, VA.

Giles County's many creeks, branches, and 37 miles of the New River often presented a challenge for transportation. A number of ferries were located on the New River beginning as early as 1780. This ferry, located near Castle Rock in Pembroke, is where tourists crossed the river from the railroad on their way to Mountain Lake. Many of the ferries, including this one, were replaced by bridges at the same location. (GCHS.)

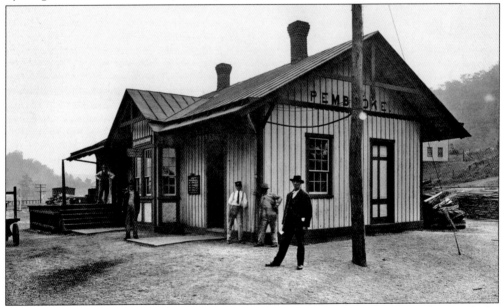

The Norfolk and Western Railway station at Pembroke was once a busy place. Along with the usual freight traffic, passenger traffic was brisk at this station. Visitors to Mountain Lake would be met at Pembroke Station by a carriage for the ferry trip across the New River and up the winding mountain road to the resort. (DLA-NS.)

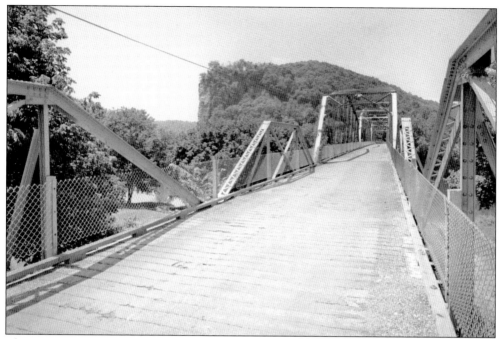

The New River Bridge on Route 623 in Pembroke served traffic from 1916 until its replacement in 1996. The bridge's seven spans and four different varieties of trusses gave it the distinction of being the automotive bridge with the greatest number and variety of truss types in Virginia, including the longest Pennsylvania Petit through-truss. The 792-foot bridge replaced the Pembroke Ferry at Castle Rock. (HAER VA, 36-PEMB.V.)

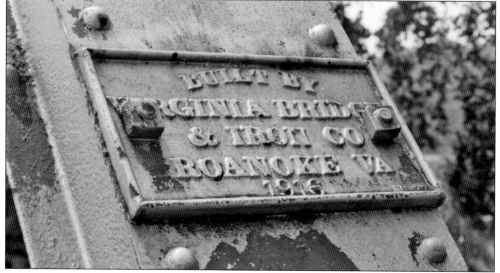

The New River Bridge was built in 1916 by the Virginia Bridge and Iron Company, at that time the second largest industry in Roanoke. The company also had plants in Atlanta and Memphis and specialized in building railway cars, heavy railroad bridges, and structural steel. Virginia Bridge and Iron Company ultimately became a subsidiary of United States Steel and was moved to Pittsburgh, where it operates independently today as the American Bridge Company. (HAER VA, 36-PEMB.V.)

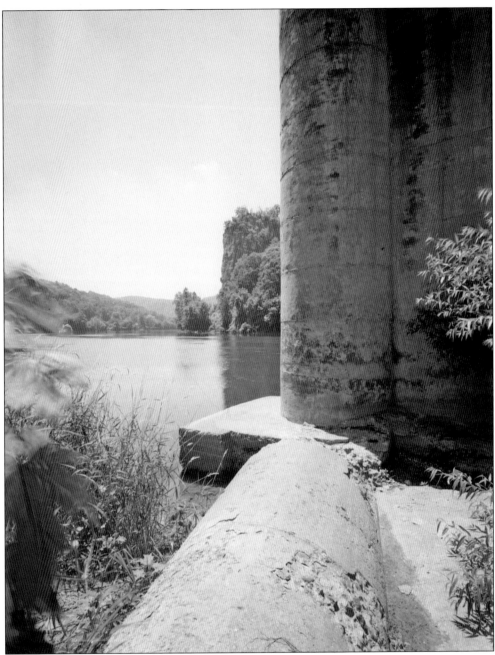

This view of one of the concrete piers of the New River Bridge at Pembroke shows Castle Rock in the background. The pier lying in the water in the foreground was damaged during a flood while the bridge was under construction. The pier had been put in place but not yet secured. When floodwaters knocked the pier over, it was easier to abandon the pier where it was and erect a new one in its place. (HAER VA, 36-PEMB.V.)

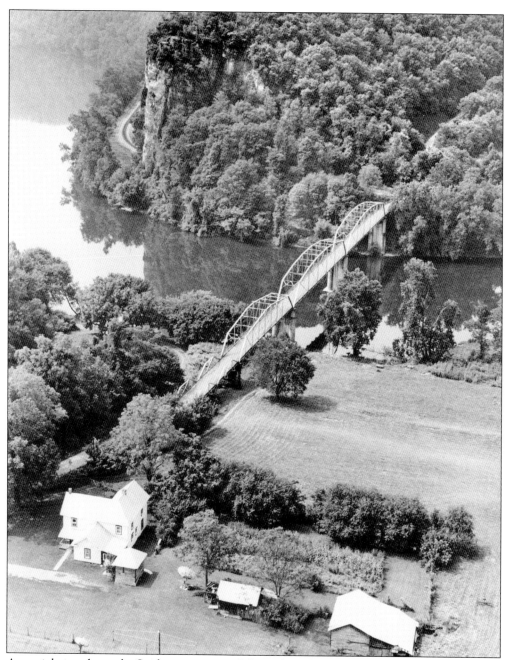

An aerial view shows the Snidow property and the early-20th-century truss bridge across the New River at Pembroke. To the left, the Norfolk and Western Railway tracks can be seen entering the tunnel at Castle Rock. There were once four other similar bridges across the New River in Giles County. This bridge stood 35 feet above the water on the east side of the river and 45 feet above the water on the left, creating a two-percent grade. Route 623 crossing the bridge was once a main route through Giles County connecting to Pulaski County. (HAER VA, 36-PEMB.V.)

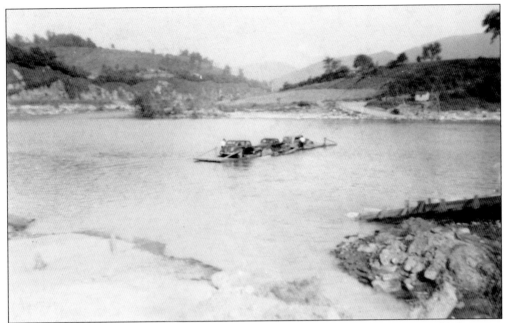

When the Celanese Corporation plant opened east of Narrows in 1939, workers could choose to ride the three-car ferry across the New River at Bluff City. Their other choice was to drive north to Narrows, cross the bridge there, and return south on the other side of the river. A bridge was built at Bluff City in 1942. (PPL.)

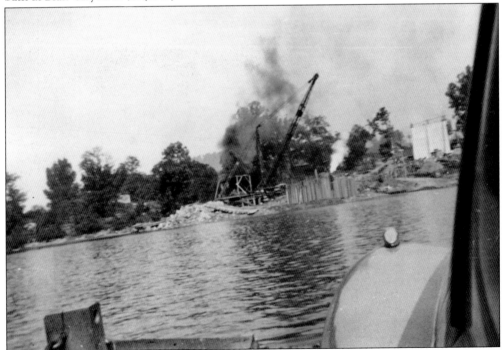

The bridge at Bluff City, replacing the ferry, greatly improved access to the Celanese Corporation plant. This photograph shows the bridge abutments being constructed in the New River. Drivers cross the bridge today as the eastbound lane of Route 460. (GCHS.)

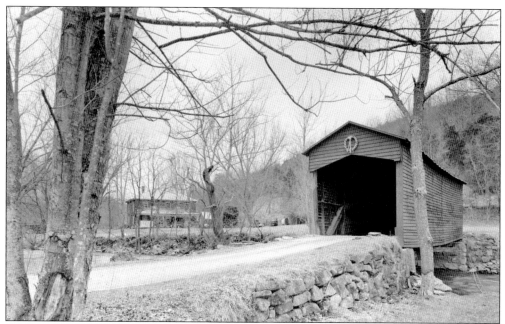

Of the nine covered bridges remaining in Virginia, three are in Giles County, all spanning Sinking Creek near Newport. Shown is the Link Farm covered bridge, built in 1912 by the Wingo brothers, who were hired by the state to build four one-lane covered bridges across Sinking Creek. The 50-foot bridge is visible on Mountain Lake Road. (HAER VA-126.)

The Sinking Creek covered bridge, built in 1916, spans 70 feet on Clover Hollow Road. Bridges were built with roofs to protect and maintain the structure, but the roofs also created a private space, and the structures became known as kissing bridges. This bridge has been restored and is open to the public with picnic grounds nearby. Covered Bridge Day celebrations are held here annually. (TKN.)

This view across the New River toward the Virginian Railway tracks at Eggleston shows the remains of the automobile bridge after the flood of 1940. The tops of the bridge piers are all that remains in the still-flooded river. (GCHS.)

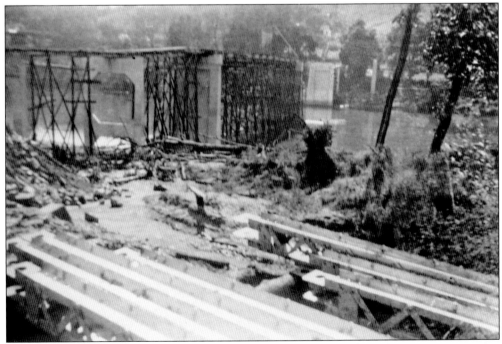

A new bridge was soon built using overhead trusses from a bridge at Schoolville, Virginia, after the 1940 flooding of the New River at Eggleston. The bridge gave the road an unusual and dangerous sharp curve. A new bridge was built at a slightly different location in 1980, eliminating the curve. (GCHS.)

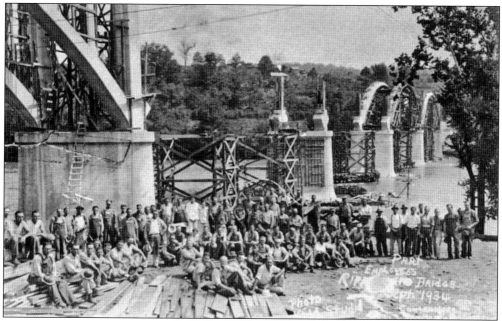

The crew is building Ripplemead's second bridge across the New River in 1934, replacing the 1899 bridge located just upstream. Completed in 1935, the bridge boasted the longest concrete arch span in Virginia at the time of its construction. In 1974, the bridge on U.S. 460 was replaced upstream from the previous span with two continuous steel span bridges that take traffic 100 feet above the river. (GCHS.)

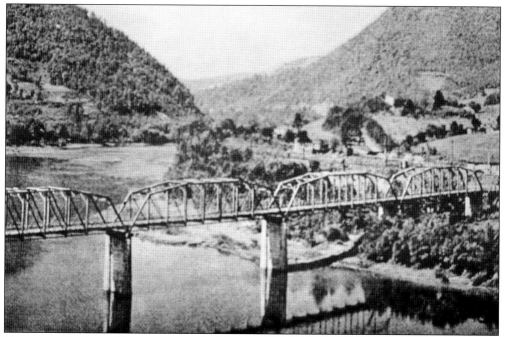

The second bridge to Narrows across the New River is shown here. The bridge was built in 1918 after the first span, built in 1911, was washed away by a flood in 1916. The old ferry was used between 1916 and 1918, while the second bridge was being built. (NCC.)

The old 1918 bridge to Narrows is shown still in use during the construction of Memorial Bridge in 1951. The new bridge was built to accommodate increased traffic to Narrows caused by the increased population of the area when the Celanese Corporation plant was built. The Virginian Railway tracks are shown in the foreground, the location of U.S. 460 today. (CGT.)

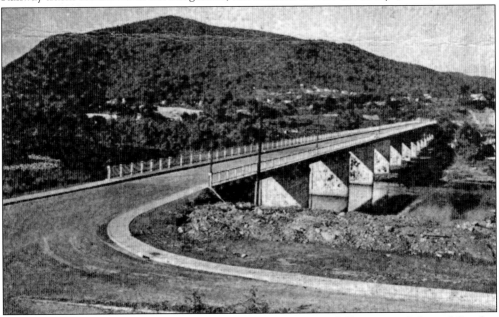

Narrows Memorial Bridge, a memorial to Giles County's veterans of all wars, was dedicated October 13, 1951. The dedication was an important event that included local politicians, representatives from the State Highway Commission, a parade, a concert, an invocation, and a dedicatory address. The bridge, still in use today but nearing the end of its lifespan, is 1,268 feet long and was built at a cost of $500,000. (RCPL.)

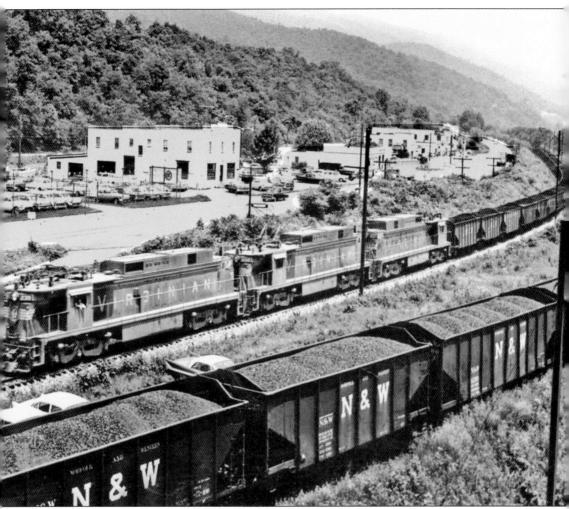

Because this photograph shows Virginian Railway and Norfolk and Western train cars on the same side of the New River, it likely dates to the period between their merger in 1959 and the end of electrified trains in 1962. Businesses and traffic are shown on U.S. 460 in Narrows, where commerce still thrives. The Virginian Railway tracks were removed in this area and the railroad bed used to widen U.S. 460 to four lanes in 1972. Just east of here, the former Virginian Railway tracks connect with a new railroad bridge so that Norfolk Southern can use the tracks on both sides of the New River. (NCC.)

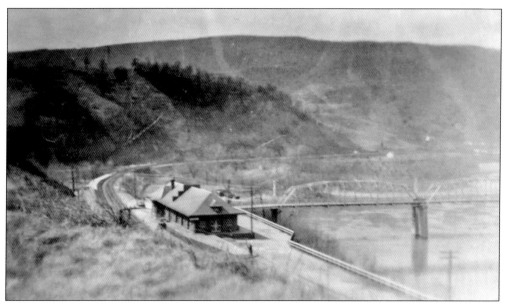

The 1918 Narrows bridge crossed the New River from U.S. 460 directly to the Norfolk and Western Railroad station. From there, drivers made a sharp right turn, followed the railroad tracks, and made a hard left turn to pass under the tracks and enter downtown Narrows. Narrows Memorial Bridge made the entrance to town more straightforward but bypassed the railroad station entirely. (CGT.)

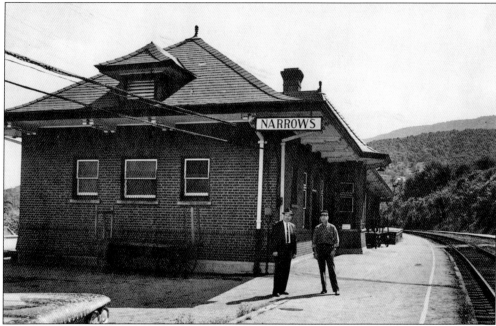

The Norfolk and Western Railroad's New River Railroad extended service to the Pocahontas coalfields in 1883. This new branch followed the New River, creating railroad towns at places such as Narrows. Passengers, rail, and freight were handled at the Norfolk and Western depot. The last passenger train was in 1979. Today's coal trains no longer stop but are frequent reminders of the bustling past. (DLA-NS.)

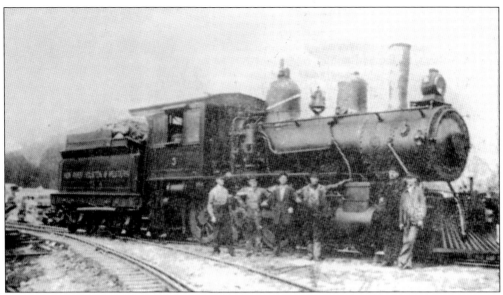

Beginning in 1901, the New River, Holston, and Western Railroad operated from a connection with the Norfolk and Western Railway in Narrows and up Wolf Creek, connecting to Rocky Gap and Suiter by 1914. The train stopped at Narrows, Talmash, Penvir, Bridge No. 2, First Ford, Chapel, Niday, Round Bottom, Rocky Gap, Novis, Hicksville, Bastian, and Suiter. This 1914 photograph shows Old No. 3 with its crew, (from left to right) Bud Hale, Clyde Coburn, Lon McGinley, Tom Wall, Ess Robertson, and Bill Hale. (NCC.)

The New River, Holston, and Western Railroad was built to reach minerals, timber, and tan bark in western Giles County and Bland County and included one passenger car. Passengers made the all-day trip to Rocky Gap, packing lunches or buying food from farmhouses along the way. The railroad followed today's Memorial Boulevard and crossed today's high school football field to reach Wolf Creek. Norfolk and Western Railway took over the railroad in 1917, operating it as the Narrows Branch. When the track was removed in 1946, the rail bed became Route 61. (DLA-NS.)

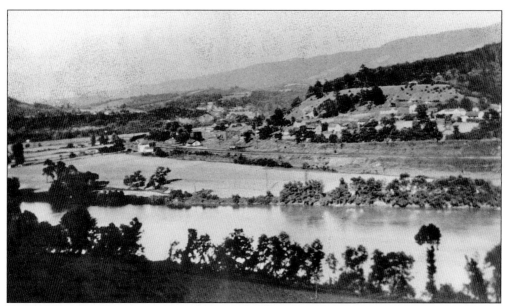

Lurich, thought to have been named by a railroad worker for a girl named Lou Richardson, is located just east of Glen Lyn on the western side of the New River along the Norfolk and Western Railway line. Before the Virginian Railway was built on the eastern side of the river, Lurich was a chief shipping point for Monroe County, West Virginia. Extra engines were stationed here to help heavy trains make the steep grade up East River Mountain and into Bluefield. (DLA.)

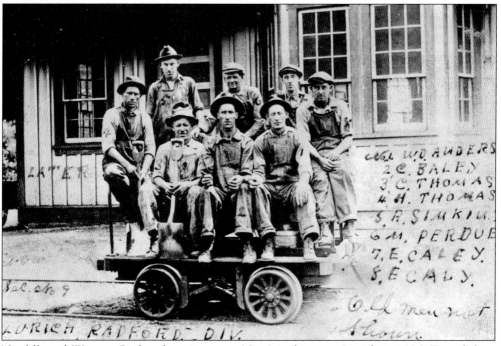

Norfolk and Western Railroad section gang No. 9 is shown at Lurich in 1896. From left to right are (first row) C. Thomas, C. Baley, and W. D. Anderson; (second row) H. Thomas, R. Simkins, M. Perdue, E. Caley, and E. Caly. The writing on the photograph reads, "Old men not shown." (DLA-NS.)

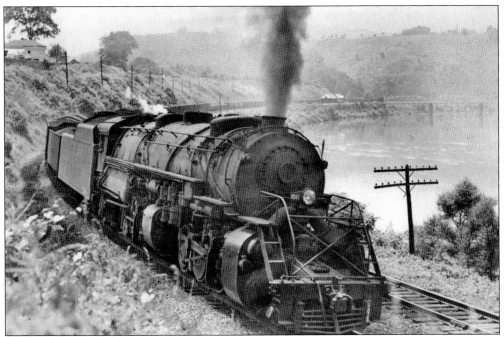

A Norfolk and Western Railway steam-powered coal train is shown just east of Narrows station in 1946. Norfolk and Western replaced steam trains with diesel during the 1950s, with the last scheduled run in 1959. Diesel locomotives now pull cars carrying coal and other commodities. (DLA-NS.)

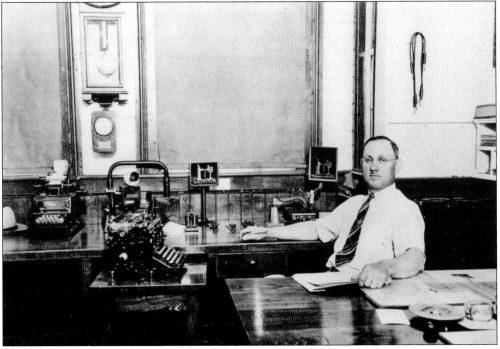

J. E. Price, agent for Norfolk and Western Railway at the Glen Lyn depot, is shown at work in 1941. On his desk are the tools of his trade: a typewriter, an adding machine, and a telegraph machine. The train schedule is marked by the clock on the wall. (DLA-NS.)

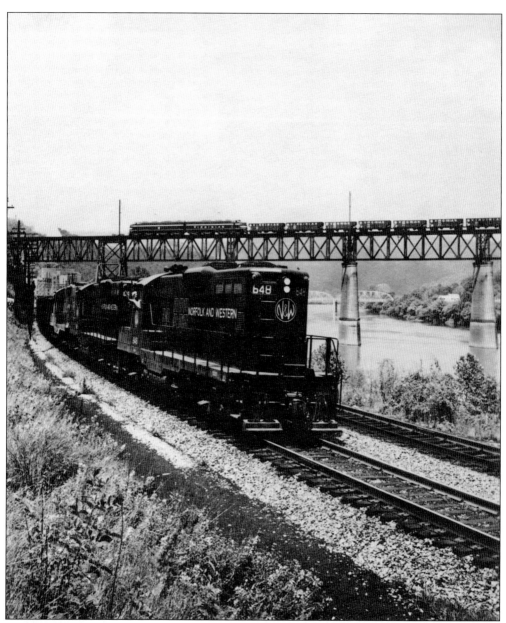

At Glen Lyn, the Virginian Railway was elevated over the Norfolk and Western Railway and the New River. The concrete piers of the trestle once made it the highest in the world. *Ripley's Believe It or Not* once listed Glen Lyn because two trains, one traveling on each track, could cross two rivers and two trestles and be in two counties and two states at the same time. (DLA-NS.)

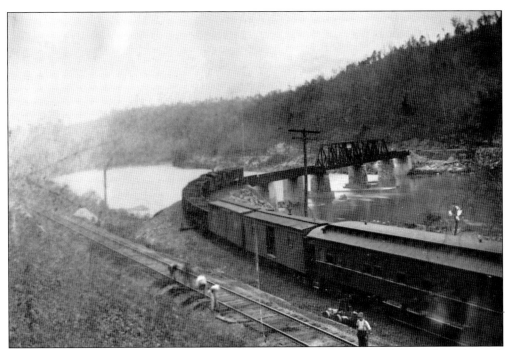

A train is shown crossing the New River bridge at Norcross between Pearisburg and Ripplemead. The Big Stony Railroad used this bridge to connect from the Norfolk and Western Railway tracks to the tracks following Big Stony Creek to Paint Bank. (GCHS.)

Big Stony Railroad was extended from the Norfolk and Western Railroad tracks at Ripplemead up Big Stony Creek to Interior in 1896. The land following the creek bed created an easy grade to reach the mountain timber stands. The railroad was extended 27 miles to Paint Bank in Craig County by 1909 and renamed the Potts Valley Branch, or the "Punkin Vine." By the 1930s, much of the track had been removed. (GCHS.)

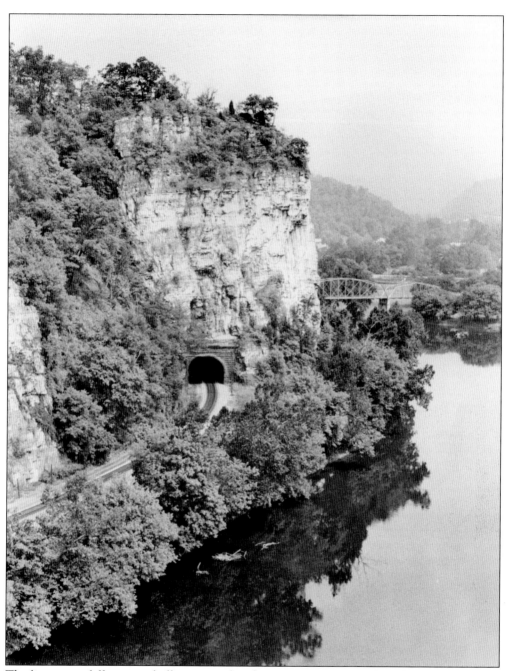

The limestone cliffs were a challenge to railroad engineers trying to follow the gentle grades of the New River. Tunnels such as this one at Castle Rock in Pembroke were built through the cliffs rather than creating steep hills or sharp curves for the trains to negotiate. Tunneling was hard work in the 1880s, creating bottlenecks such as the one during the construction of the tunnel at Eggleston, which caused workers to name the community Stay Tide. (HAER VA, 36-PEMB.V.)

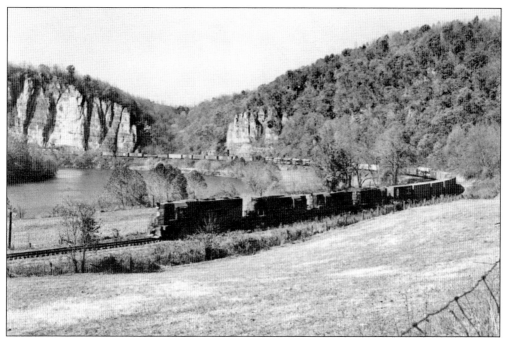

Eggleston was once a transportation hub with Norfolk and Western trains traversing the western side of the New River and the Virginian Railroad traversing the eastern side. This photograph shows a Virginian train and the limestone cliffs of Eggleston. Construction of the Virginian Railway in 1909 forced the relocation of the Eggleston Springs Hotel away from the river and decreased the desirability of the resort to visitors. (DLA-NS.)

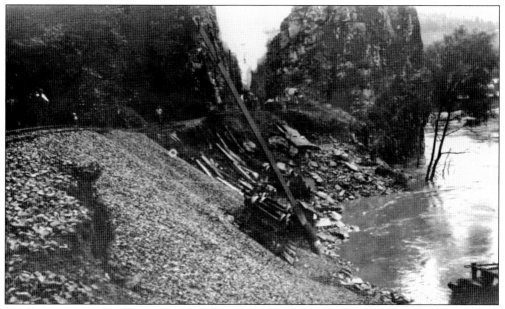

The beauty of the New River can turn destructive in times of flooding. The flood of 1940 washed out the Virginian Railway where it cuts through the limestone cliffs at Eggleston. A coal car can be seen upside down on the bank of the river with an upended telegraph pole underneath it. (GCHS.)

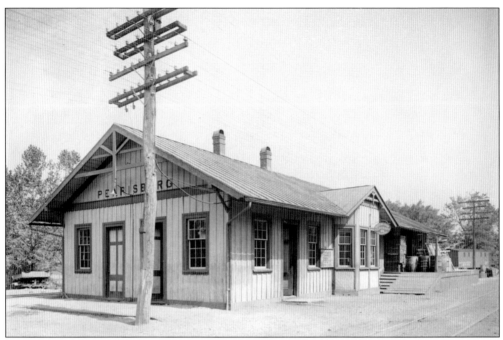

The Norfolk and Western train stations of Giles County, with the exception of Narrows, look remarkably similar. All were frame stations with board-and-batten siding and had similar details on the gable ends, doors, chimneys, and front facade. Pearisburg's station and Eggleston's stations (shown below) were nearly identical. (DLA-NS.)

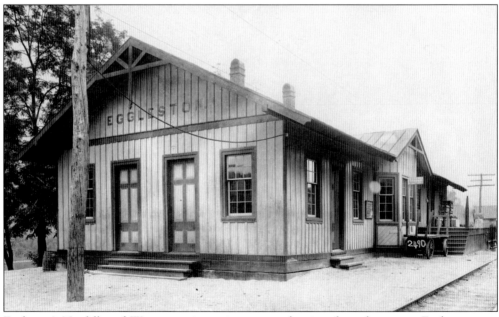

Eggleston's Norfolk and Western train station, across the river from downtown Eggleston, was a major shipping point for southern Giles County from Newport to White Gate. Stock pens and loading platforms facilitated shipments of livestock, produce, merchandise, and passengers. Passengers bound for the hotel crossed the river by ferry. (DLA-NS.)

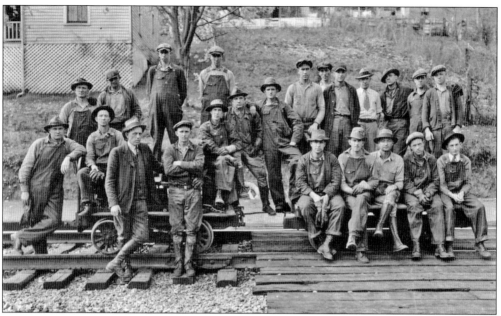

Railway signalmen are shown at Eggleston in 1929. C. P. Black was foreman. In the days before automation, railway signalmen were responsible for physically changing signal lights that told train crews a route was safe. Signalmen also checked for a red light hanging from the back of the train as it passed that indicated that the train had not lost any cars. The signalmen of today install, repair, and maintain the automated switches and signals that enable trains to move safely. (DLA-NS.)

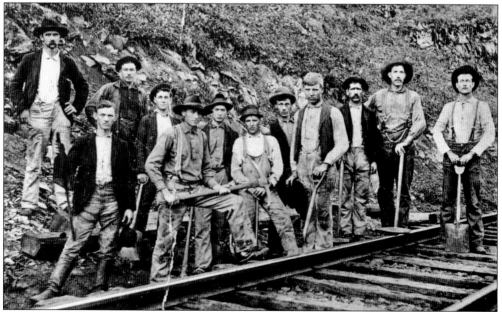

The Norfolk and Western Railway section force is shown at Ripplemead in 1896. As indicated by their picks and shovels, the section force was responsible for the maintenance of the railroad tracks, bridges, crossings, signals, buildings, and water supplies. For a single-track railroad, the section gang was responsible for five to seven miles of track. (DLA-NS.)

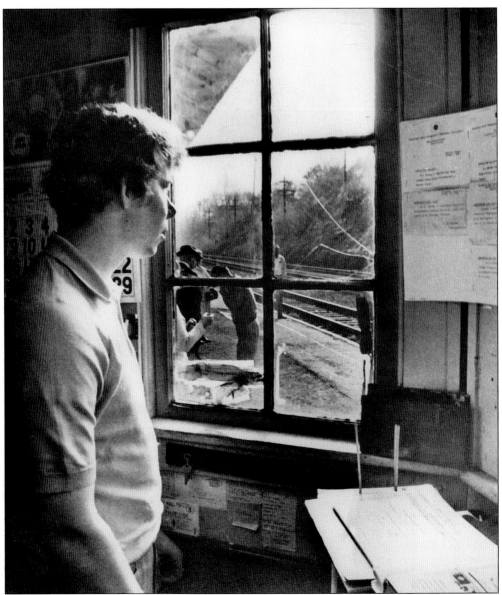

Passenger agent Art Hawley is shown in 1971 at Pearisburg station awaiting the last run of the *Pocahontas*, the Norfolk and Western Railway's last scheduled passenger train, from Norfolk to Cincinnati. Amtrak provided passenger service to Narrows on the Norfolk and Western tracks until 1979. Several excursion trains ran from Roanoke to Bluefield, but such trips were discontinued in 1994. (DLA-NS.)

Four

INDUSTRY
A TIME FOR WORK

The natural resources of Giles County have made it an ideal place for a variety of industries. In the 1800s, grist, lumber, woolen, and other mills settled along the creeks, using the water to power their machinery. An old iron furnace in Newport stands as testimony to an industry that thrived there briefly in the 1870s until the difficulty of transporting the pig iron over the mountains to the then-closest railroad connection at Christiansburg, 18 miles away, became apparent. The arrival of the railroad in Giles County increased industry, because the transportation of goods became easier. Large stands of timber were removed prior to 1930 in places like Interior to create railroad ties and automobile bodies. Large limestone deposits are still being quarried to provide commodities such as agricultural lime, plaster, and the basis for sheetrock. Industries such as Leas and McVitty New River Tannery, Appalachian Power Company, and Celanese Corporation of America built facilities along the New River in Giles County to use the water and take advantage of nearby railway transportation.

The Sinking Creek Furnace in Newport melted iron ore mined on Sinking Creek Mountain to create iron ingots for industrial use. The iron was melted in the limestone furnace shown here by burning charcoal, resulting in a chemical reaction that created metallic iron. There were at least six charcoal kilns in the area to supply the furnace. The iron furnace employed about 200 people during the 1870s. (GCHS.)

Web Mason and Mr. Trout are shown surveying the limestone deposits at the Ripplemead Lime Company in 1934. Limestone cliffs are plentiful on the New River, providing many opportunities for quarrying. The underlying limestone also means that Giles County has caves and sinkholes that are a challenge to builders. (GCHS.)

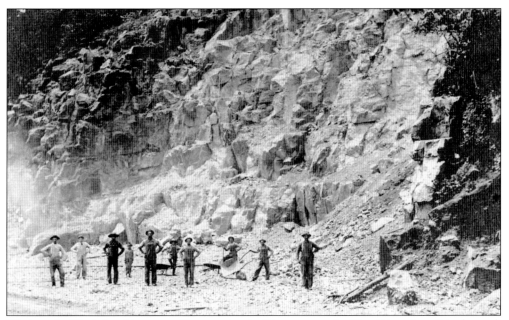

Workers for Virginian Limestone Corporation in Klotz, across the New River from Ripplemead, used picks, shovels, and wheelbarrows to quarry limestone in the early days. Klotz was named for C. A. Klotz, who ran the Virginia Limestone Corporation when it opened in 1916. One of many lime companies in Giles County, the Virginian Limestone Corporation was originally formed to supply ballast for the Virginian Railway. (GCHS.)

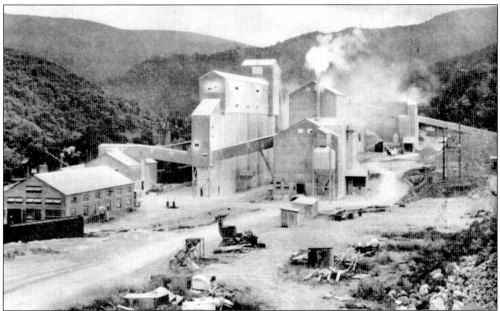

The National Gypsum Plant is shown in Kimballton in the 1950s. The plant opened in 1947 to produce hydrated limes and pulverized limestone for use in steel mills, production of carbide, water purification, mine dusting, and farming. National Gypsum Company also produced Gold Bond brand gypsum wallboard. Today the plant is owned by Chemical Lime and continues to produce hydrated lime, lime slurry, and quick lime. (GCHS.)

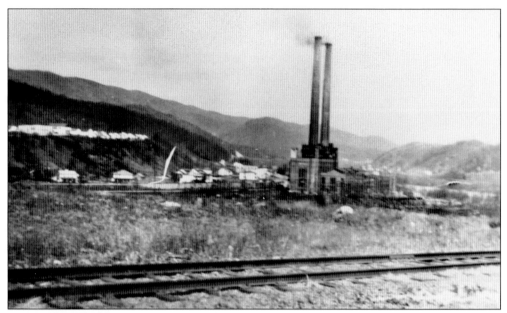

The Virginian Railway was begun by coal baron Henry Huddleston Rogers in 1904 as the Tidewater Railway. Because the work was self-financed, the Chesapeake and Ohio Railroad and Norfolk and Western Railway were not aware that a competing railroad was being built until work was well under way. By 1909, the Deepwater Railway in West Virginia and the Tidewater Railway in Virginia had been connected and incorporated as the Virginian Railway, running 443 miles from Deepwater, West Virginia, to Sewell's Point, Virginia. (CGT.)

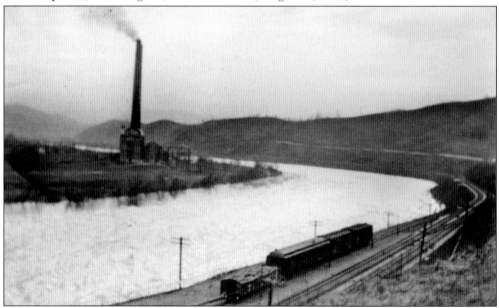

In Giles County, the Virginian Railway ran on the eastern side of the New River, while the Norfolk and Western Railway ran on the western side. Throughout its length, the Virginian Railway had slight grades, making it easier to haul large loads of coal and other commodities. A power plant was built in Narrows to electrify the railway, enabling the engines to carry ever heavier loads. (CGT.)

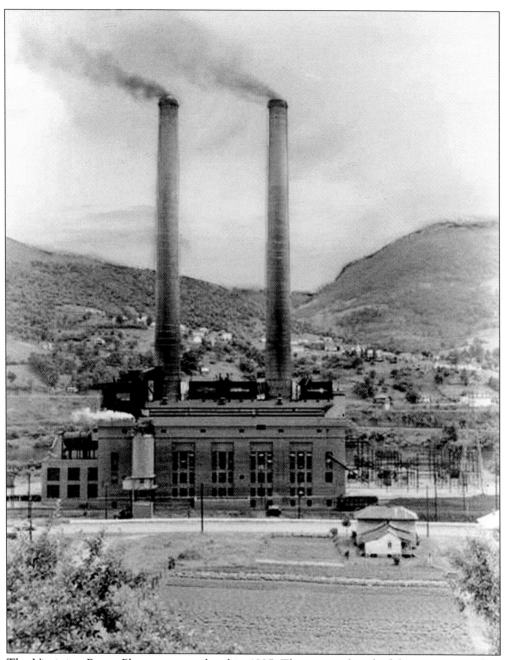

The Virginian Power Plant was completed in 1925. The power plant had four units providing 90,000 horsepower. A fifth unit was added in 1946, before this photograph was made in 1952. Without electrification, the Virginian Railway would have been more constrained by the size of the locomotives and the weight of the train. The Virginian electrification system helped engines climb the mountains between Roanoke, Virginia, and Mullens, West Virginia. (NCC.)

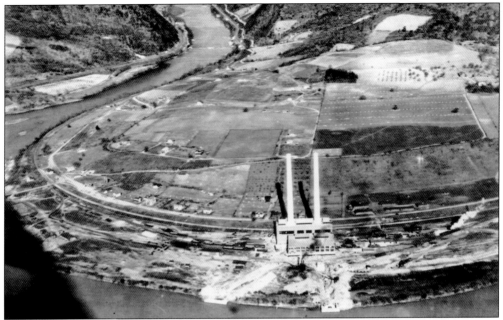

This 1922 aerial photograph shows the Virginian Power Plant during construction. The road to downtown Narrows is seen heading toward the New River on the far left. The long buildings to the right of the smokestacks housed convicts improving roads through the county. Narrows High School and houses originally built for Celanese Corporation workers are now located on the hill behind the power plant. (GCHS.)

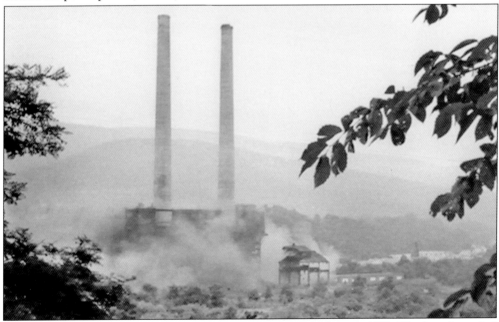

The Virginian Railway merged with Norfolk and Western Railway in 1959. The last electrified train ran between Roanoke, Virginia, and Mullins, West Virginia, in 1962. A new railroad bridge was built across the New River one mile east of Narrows to connect the tracks. Norfolk Southern continues to use the tracks on both sides of the river. (NCC.)

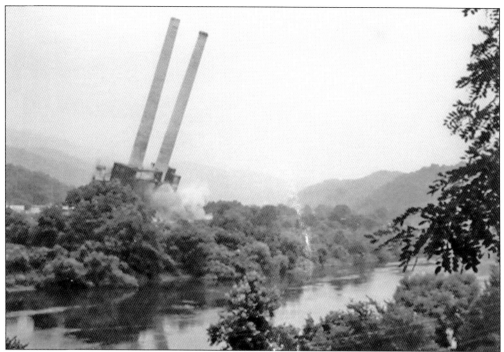

With no more need for the Virginian Power Plant, the building was imploded in 1970. It took two attempts for the well-known Controlled Demolition, Inc., of Towson, Maryland, to topple the plant and its 310-foot smokestacks. The company vice president said that the power plant was the sturdiest building they had demolished up to that time. The former Virginian Railway tracks between Narrows and Glen Lyn were removed to make space for Route 460 to expand to four lanes. (NCC.)

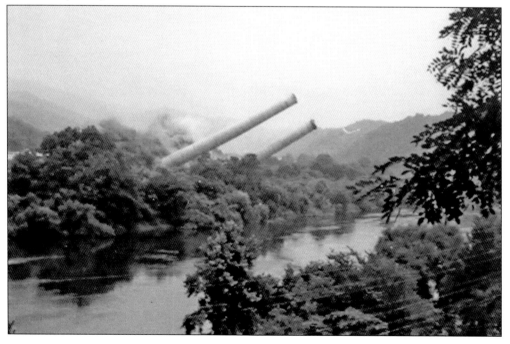

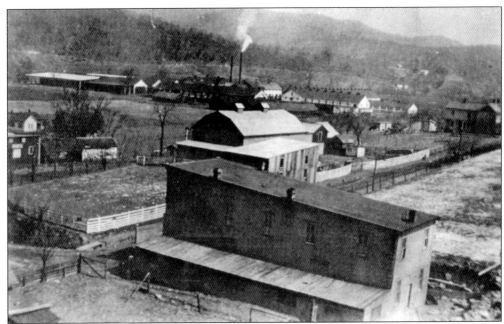

This view from near the George Pearis Cemetery shows Bluff City in 1914. In the foreground is the Thomas Mercantile Company store. Leas and McVitty New River Tannery is in the background. The tannery was opened in 1895 to manufacture heavy sole leather for boots and shoes. The tannery burned to the ground in 1976. (GCHS.)

Rental houses were built on the W. H. Thomas farm near the Leas and McVitty New River Tannery by 1914 to help alleviate a worker shortage caused by the lack of available housing. The dirt road, today's Route 100 heading north to Narrows, was once the main highway through Giles County. (GCHS.)

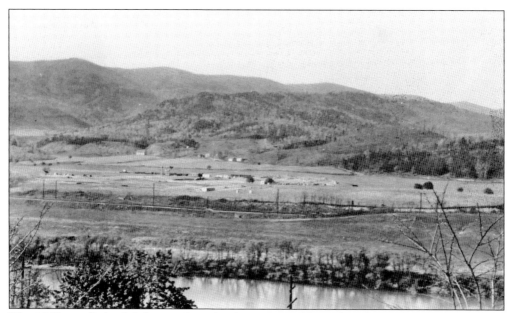

The 1,232-acre Raleigh Johnston farm, land once owned by early Giles County settler Mitchell Clay, was purchased in 1939 to become the site of the Celanese Corporation of America chemical plant. The site was chosen for its access to the water of the New River, railroad transportation, labor supply, climate, and natural resources. (PPL.)

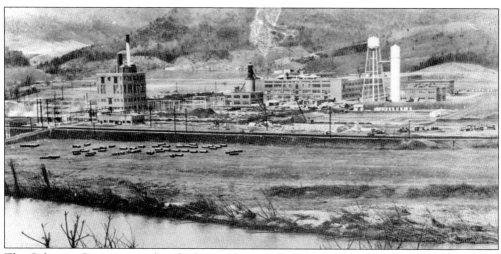

The Celanese Corporation plant had recently opened when this photograph was made in 1941. Taking just eight months to build, the plant began production of acetate staple filaments for cigarettes in January 1940. It employed 869 in 1940. By 1948, the plant had 4,600 employees. (DLA.)

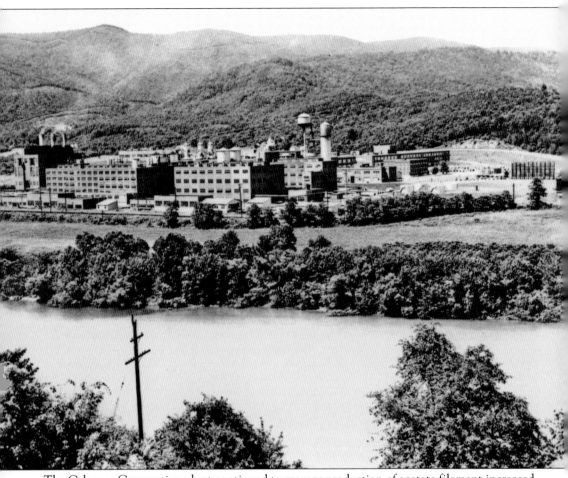

The Celanese Corporation plant continued to grow as production of acetate filament increased, though the number of employees had decreased to 931 in 2004. The company reported in 1964, its 25th anniversary in Giles County, that enough acetate yarn had been produced to reach from the earth to Pluto. (PPL.)

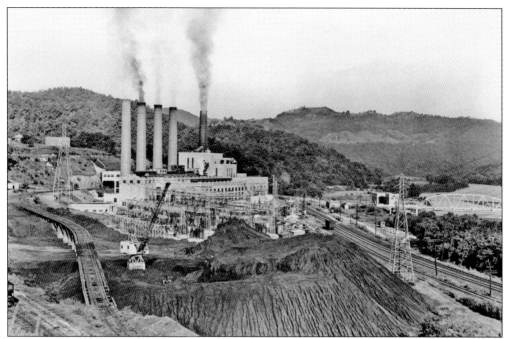

The Appalachian Power plant in Glen Lyn has continued to grow in response to increasing electric power needs. When this photograph was taken in 1944 during World War II, the addition of two boilers and a new unit had increased power output from 100,000 kilowatts to 180,000. Note the huge piles of coal in the foreground. (DLA-NS.)

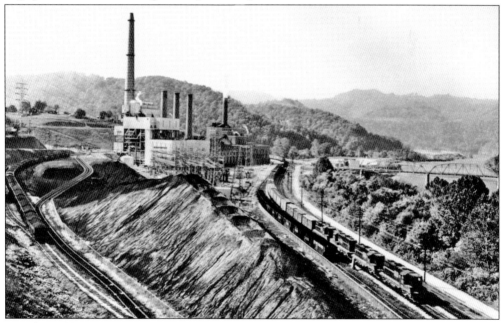

Another addition to the Appalachian Power plant in Glen Lyn, completed by 1960, added a 225,000-kilowatt unit (with the tallest smokestack), more than doubling the capacity of the power plant. Today the plant produces 340,000 kilowatts, consumes 700,000 tons of coal per year, employees 95 people, and injects millions of dollars into the local economy. (DLA-NS.)

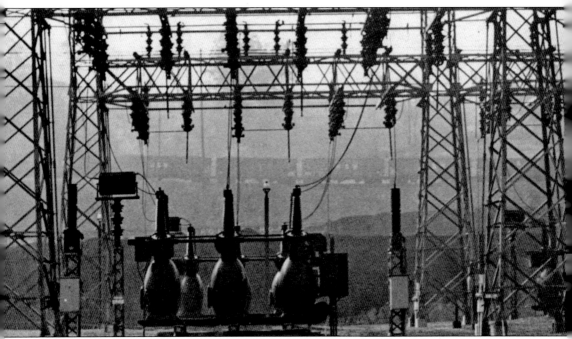

This unusual view from an Appalachian Power advertisement shows electric transformers in the foreground, piles of coal that provide the power in the middle ground, and the Norfolk and Western trains that deliver the coal in the background. The Appalachian Power plant in Glen Lyn has been providing power to area residents since 1919. (DLA-NS.)

Five

LEISURE
A TIME FOR PLAY

The people of Giles County work hard, but they find plenty of opportunity for leisure as well. They are sports lovers, with many people found at Friday night high school football games rooting for the home team. Before the county consolidated into two high schools, even more rivalries existed, and the teams were even more intensely local. Baseball teams such as the New River Rebels and the Bluff City Ducks let student athletes continue to play well into adulthood. The natural beauty of the mountains, creeks, and New River provide numerous opportunities for hiking, camping, hunting, and fishing. Several corporations took advantage of the beautiful scenery and climate in Giles County, building resorts in the early 1800s to attract tourists. In a time when springs resorts were popular along the Virginia and West Virginia border for people seeking to cure ailments with the healing waters of the local springs, places like Eggleston Springs and Mountain Lake resorts became popular. Though Eggleston Springs is long gone, Mountain Lake continues to thrive, selling the beauty of a mountain escape.

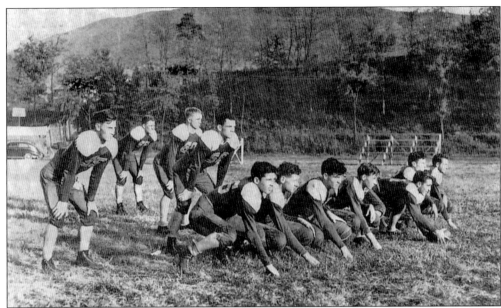

Sports have always been an important leisure activity in Giles County. The larger schools like Narrows High School and Pearisburg (now Giles) High School have fielded championship football teams over the years. The Narrows High School football team is shown in their 1939 undefeated season. On Friday nights, the most popular place in town is still the high school football field. (GCHS.)

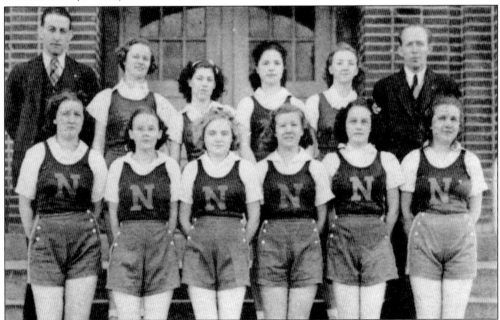

For many years, the only sport women were able to play in school was basketball. Shown is the 1939 Narrows High School women's basketball team with coaches G. R. Hall and W. J. King; starters are "Spark" Beamer, Dorine Hare, Sue Johnson, Ruth Lucas, Sara Bane, and Doris Gearheart; and substitutes are Jeanette Williams, Dorothy Blankenship, Peggy Day, Ruth Bonham, Virginia Johnson, Maxine Crumb, and Marion Bowen. (GCHS.)

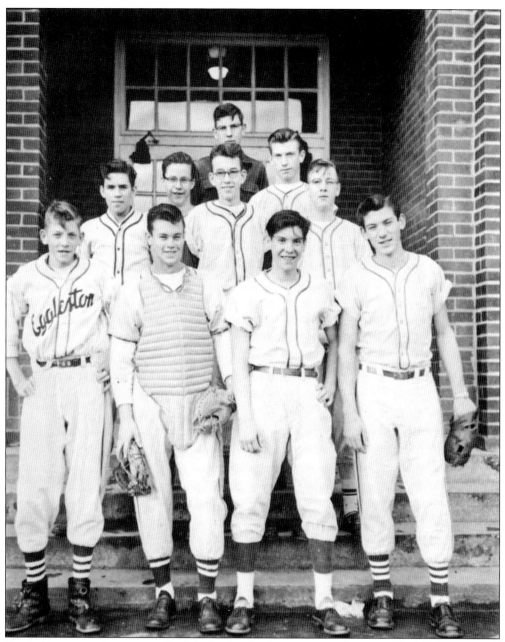

Baseball was popular among all of the high schools, no matter their size. The Eggleston High School baseball team is shown in 1957. In the time when most of the small communities in Giles County had their own high schools, there were enough baseball teams to compete as a league within the county. Residents rallied around their hometown teams, creating rivalries and improving the sense of community. (GCHS.)

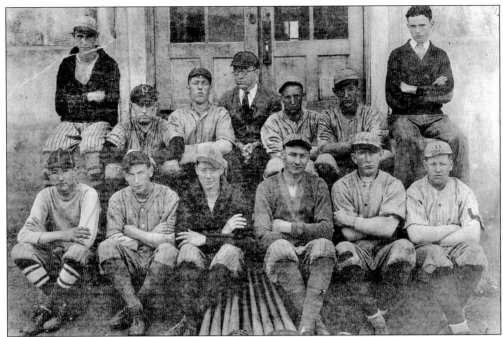

The Pembroke High School baseball team is shown in 1928. The team was called "Shorty's Boys" for coach Mervin "Shorty" Williams, shown in the center of the top row. From left to right are (first row) Clarence Criner, Emmitt Cruise, Claude "Buck" Sibold, Frederick Lee Johnston, Ralph Miller, and Robert Gilmer; (second row) Charles Williams, unidentified, Eugene Gilmer, Charlie Brooks, Wilson Porterfield, and Newton Walters. (GCHS.)

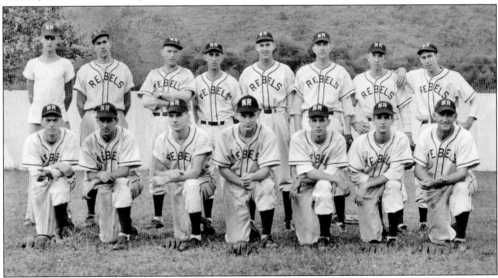

Giles County was home to the minor-league New River Rebels, an Appalachian League team that played at Ragsdale Field in Narrows from 1946 to 1950, winning the league championship in 1946 and 1947. The 1946 team is shown from left to right: (first row) Don Edwards, Dick Weigle, Harry Bushkar, Johnny Kruckman, Earl Daniels, Dick Callison, and Bob Hall; (second row) Luke Landers, Bernie Graybill, manager Jack Crosswhite, Harry Crosswhite, George Surber, Shannon Hardwick, Bill Davies, and Dick Mayer. (GCHS.)

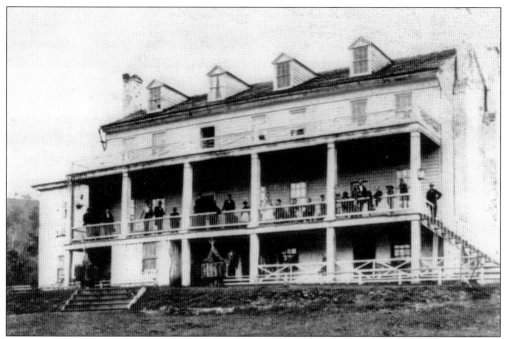

The first Mountain Lake Hotel was known as Salt Pond Hotel. Shown here around 1880, prior to any additions, it was constructed in 1856. Mountain Lake, or Salt Pond, was discovered by explorer Christopher Gist in 1751. Henley Chapman, owner of Eggleston Springs, convinced the legislature to incorporate the Mountain Lake and Salt Sulphur Springs Turnpike Company to improve the roads, and Mountain Lake Resort was born. (GCHS.)

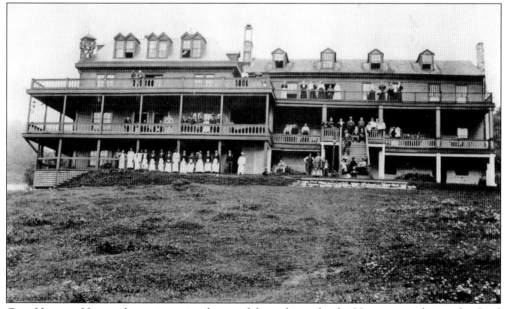

Gen. Herman Haupt, the engineer in charge of the railways for the Union army during the Civil War and founder of the Southern Pacific Railway, purchased Mountain Lake Hotel in 1869. He built a new, larger hotel, shown to the left in this 1889 photograph, as an addition to the earlier building still visible on the right. (GCHS.)

Visitors to Mountain Lake came by way of carriage or stagecoach, as can be seen in the background of this 1890 photograph. Travel was dusty and rough, with passengers at the mercy of the rutted dirt-road conditions and weather. The first thing many did upon arrival was change from their riding clothes into an outfit more suitable for resort life. (GCHS.)

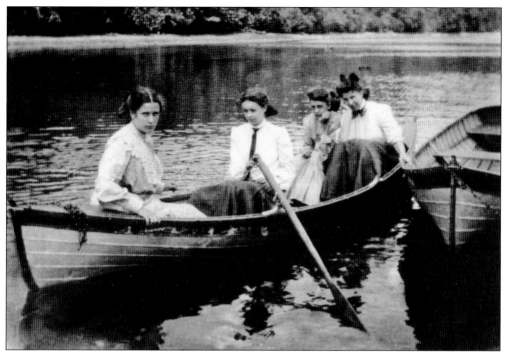

Because the level of the water in the lake has historically fluctuated, many thought there was a stopper that, when pulled, would suck those on the lake into the earth. One mother would not let her daughter go out on the lake (unlike these 1890s women) because "it is a curious sort of thing that pond! If I was on it I should feel all the time as if the bottom might fall out!" (GCHS.)

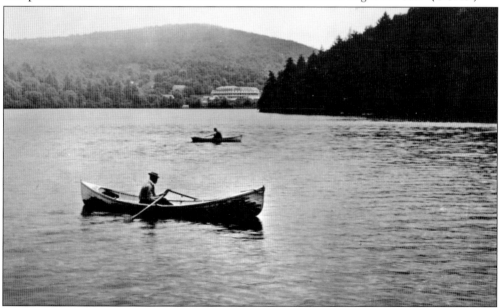

Spring-fed Mountain Lake is one of two natural lakes in Virginia. Located at 4,000 feet above sea level, it is the highest lake east of the Mississippi. Nearby views are spectacular, and the climate is cooler than the surrounding areas. This 1920 view back towards the hotel shows a full pond. In 2007, the water level was much lower. (GCHS.)

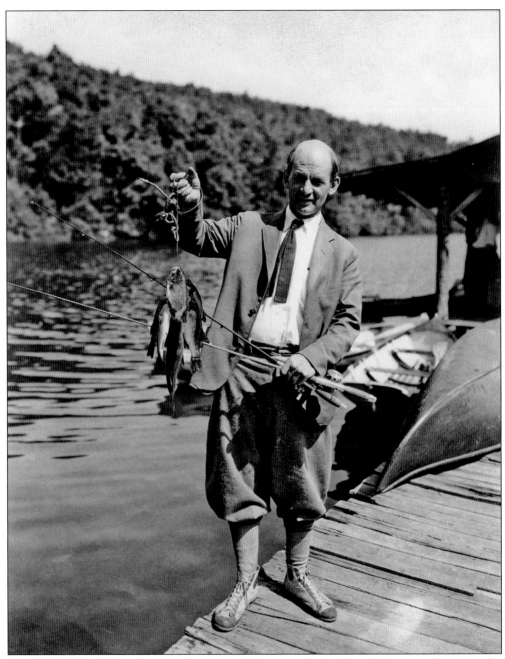

Fishing is one of many attractions to visitors of Mountain Lake. This 1929 visitor, shown on the dock near the boathouse, has had a successful day. In 1900, the lake was stocked with California trout. Today it is stocked with rainbow trout and bass. Fishermen can also visit nearby Big and Little Stony Creeks or John's Creek for mountain trout. (GCHS.)

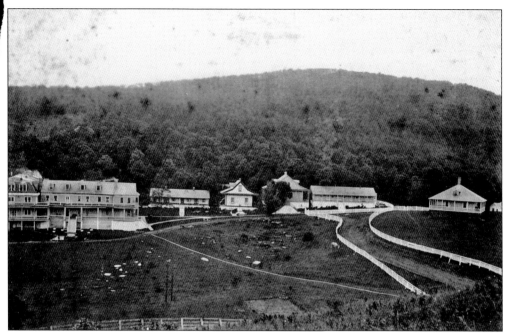

This 1920 view of Mountain Lake Resort shows the hotel to the left and some of the other cottages. The Gordon Porterfield family owned the hotel from the late 19th century until 1930. The Porterfields, with the help of T. A. Taylor, Martin P. Farrier, and F. E. Dunklee, continued to improve the hotel, adding amenities and rooms. (GCHS.)

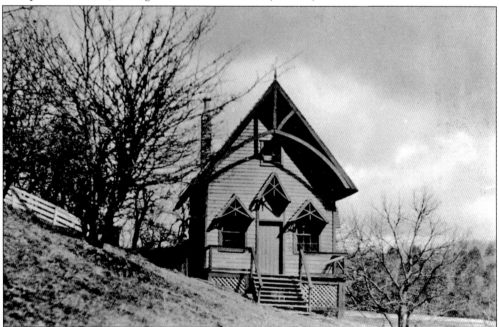

Newport cottage is shown in 1880. During Herman Haupt's ownership of the hotel, from 1870 to 1890, he built cottages, a store, a laundry, a chapel, dormitories, boat- and bathhouses, a bowling alley, a billiard room, and a mill and other services necessary to run a self-sufficient resort. He also added the luxury of running water to the hotel. (GCHS.)

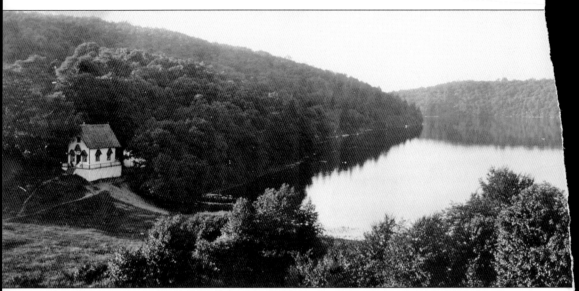

This panoramic view from the hotel towards Mountain Lake shows a nearly full lake. The lake sits on a basin of four different rock substrates and their many cracks. The lake is fed by springs

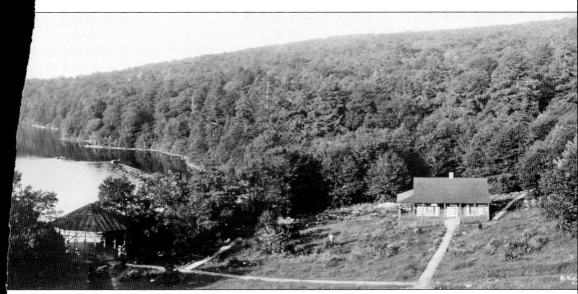

and groundwater that seeps into the cracks. In dry seasons, the water recedes significantly, while wet seasons raise the water level. (PAN US GEOG–Virginia.)

Bald Knob rises 448 feet above Mountain Lake and can be seen behind the hotel. Said to have a view of five states across a radius of 100 miles, Bald Knob is just three-eighths of a mile from the hotel. According to a pre-1900 brochure, "even invalids were able to take this walk." This young lady is shown on Bald Knob in 1870. (GCHS.)

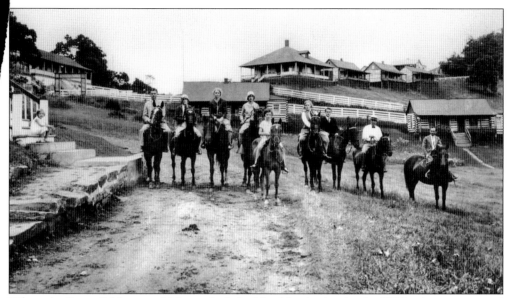

When the Porterfields owned Mountain Lake Hotel beginning in the 1890s, they encouraged frequent guests to lease land to build their own cottages at the lake. Cottage owners leased the land for $1 per year for 15 years and received discounts on meals and maid service from the hotel. At the end of the lease, ownership of the cottages reverted to the hotel. This is a 1929 view of the cottages. (GCHS.)

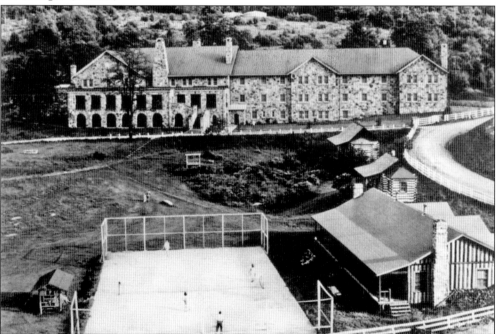

William Lewis Moody, a Mountain Lake Hotel visitor from Galveston, Texas, purchased the resort in 1930. Moody built a new hotel of native sandstone, completed in 1936, beside the old hotel, which was subsequently torn down. The film *Dirty Dancing*, using many locals as extras, was partially filmed here in 1987. A British *Dirty Dancing* reality television show was filmed here in 2007. (GCHS.)

Flem Jackson and Gene Lucas are shown bottle-feeding a deer in the Mountain Lake Hotel lobby in 1950. "House of Moody" on the mantle refers to William Lewis Moody, builder of the stone hotel. After his death, the hotel became the property of his daughter, Mary Moody Northen, and has been operated by her endowment since her death in 1986. The Wilderness Conservancy at Mountain Lake, established in 1989, protects 2,600 acres around the lake. (GCHS.)

Elks long ranged throughout North America. However, by the mid-1800s, most had been killed for food and hides. By 1926, only two elk herds remained in Virginia, one in the Giles-Bland Range. Shown here in 1935 are elks transported from Yellowstone by train to Giles County then brought to Mountain Lake for release. They bothered farmers such that by 1970, it was decided to kill the remaining 78 elks of the herd. (DLA-NS.)

In a last-ditch effort to raise money to improve the struggling Eggleston Springs Resort, the company issued stock certificates to elicit money from the public. Unfortunately, with Norfolk and Western coal trains passing on one side of the river and Virginian Railway coal trains passing on the other, the resort was no longer a peaceful getaway. (GCHS.)

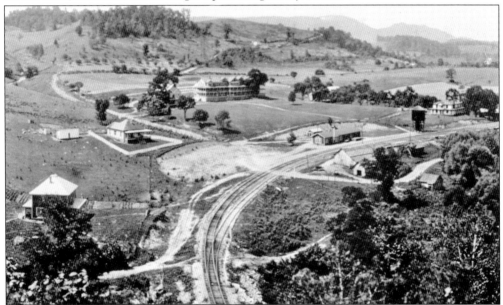

A right-of-way through the Eggleston Springs resort for what would become the Virginian Railway on the eastern side of the New River was sold in 1905. The hotel, with its 50 rooms, five halls, and double porches, was moved away from the river, and the cottages and ballroom were torn down. The new Virginian Railway station is directly in front of the hotel, shown in its new location in 1914. (PAN US GEOG–Virginia.)

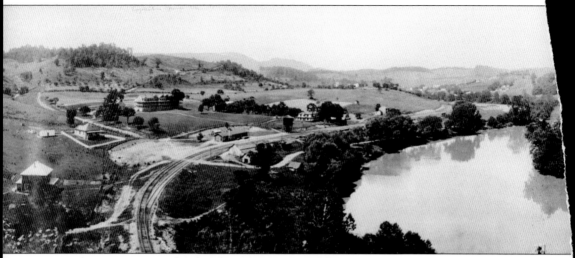

The dramatic scenery that lured visitors to the Eggleston Springs resort is shown. The hotel is to the left. The curve of the New River provided a deep, wide, and calm area for boating, swimming, and fishing. The limestone cliffs, given names such as Caesar's Arch, Pompey's Pillar,

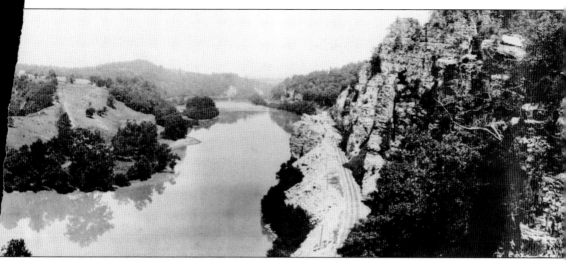

and Vulcan's Forge when the resort was known as Hygeian Springs, are shown at right. (PAN US GEOG–Virginia.)

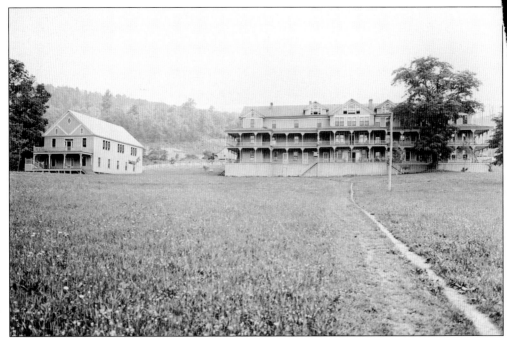

A springs resort was located at Eggleston as early as the 1830s. Variously called Gunpowder Springs, Hygeian Springs, Chapman's Springs, New River White Sulphur Springs, and Eggleston Springs, the resort catered to people seeking relief from digestive and skin disorders. The last hotel was built in 1901 then moved to accommodate a new railroad, whose noise and smoke proved to be the hotel's demise. The hotel was closed in the 1930s and was later torn down. (DLA-NS.)

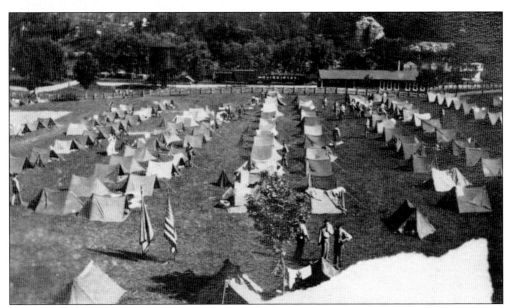

As part of their military training, members of the Virginia Tech Corps of Cadets hiked nearly 20 miles from Blacksburg to Eggleston about 1920. They spent the night in tents on the Eggleston Springs hotel lawn. A Virginian Railway train and the depot and water tower can be seen in the view from the hotel towards the New River. (DLA.)

Louise Robinson stands in front of the Cascades, a 69-foot waterfall in Jefferson National Forest near Pembroke that attracts about 150,000 visitors each year. The two-mile-long scenic Lower Trail follows the banks of Little Stony Creek to the waterfall, where brave souls swim in the cold water. Most return by way of the more direct two-mile-long Upper Trail. (GCHS.)

A brochure advertises Giant Caverns, a tourist attraction located on the north side of Wolf Creek Mountain in Narrows. The business, owned by stockholders, was opened in the 1920s and managed by Gordon Simmons. The caverns were a rapidly growing attraction visited by over 5,000 people between 1926 and 1930. (GCHS.)

A 1920s photograph of Giant Caverns in Narrows shows visitors in what was boasted to be the largest single room of any cave in Virginia. Norfolk and Western Railroad's company picnics were frequently held here, and dances were often held on weekend nights. The business was owned by stockholders who planned a resort hotel and swimming pool. These plans were dashed by the Depression, which caused the caverns to close permanently. (DLA-NS.)

Steps for visitors to enter the lower rooms of the cavern are seen to the left of the large stalagmite. Electrical wires, which supplied the lighting for nighttime activities in the caverns, can also be seen. The cave entrance was located at the end of Cave Street. Today the cavern openings are located in the Sentinel Hills subdivision. (DLA-NS.)

BIBLIOGRAPHY

Centennial History and Publications Committee. *The First Fifty Years: A History of the Town of Narrows, Virginia 1904-1954 with an Update for the Years 1954-2004.* Narrows, VA: 2004.

Giles County Historical Society Research Committee. *Giles County, Virginia: History—Families, Volume I.* Marceline, MO: Walsworth Publishing Company, 1982.

Giles County, Virginia, Web site. gilescounty.org.

Giles Research Group. *Giles County, Virginia: History—Families, Volume II.* Marceline, MO: Walsworth Publishing Company, 1994.

Goldwaithe, Eaton K., ed. *Giles County, 1806-1956: A Brief History by Robert C. Friend and Others.* Pearisburg, VA: Giles County Chamber of Commerce, 1956.

I Remember When: A Celebration of Giles County, Virginia, 1806–2006. Rich Creek, VA: Country Media, Inc., 2006.

Johnson, Patricia Givens. *Mountain Lake Resort Book: 1751–1900.* Christiansburg, VA: Walpa Publishing, 1987.

Miller, Hattie E. *A Story of Newport and Its People.* Blacksburg, VA: Copy Corner, 1978.

Olde Towne Pearisburg Register newsletters, 1994–2007.

Virginia Department of Historic Resources. Giles County National Register of Historic Places Listings.

INDEX

ACROSS AMERICA, PEOPLE ARE DISCOVERING SOMETHING WONDERFUL. *THEIR HERITAGE.*

Arcadia Publishing is the leading local history publisher in the United States. With more than 4,000 titles in print and hundreds of new titles released every year, Arcadia has extensive specialized experience chronicling the history of communities and celebrating America's hidden stories, bringing to life the people, places, and events from the past. To discover the history of other communities across the nation, please visit:

www.arcadiapublishing.com

Customized search tools allow you to find regional history books about the town where you grew up, the cities where your friends and family live, the town where your parents met, or even that retirement spot you've been dreaming about.